Noa Noa

12. D'eny Sout nes les Dieny Suivants: Elle enfanta Teirie et il était Dien Lifaton - Romanoma. Quand le Dien Roo, saisissant a il y avait declans sortit par le côté du sein de sa mère. La femme acconcha ensuite de ce qu'elle contanait encore ; il en sortit a qui s'y trouvait encore renfermé : L'initation ou présage des Tempetes la colère (ou l'Orage) la fureun ou un vent furience, la colère apaisse ou la tempréte calmée). Et la source de ces esports est dans le lien D'on sout envoyés les messagens.

Etornito- de la Matière. Dialogue entre Céfatou et Hina (les génies de la terre - et la lune. Hina disait à Fatou sufaites revive (ou ressusciter l'houme après sa mort. Fatou repond : Non jeue le ferri point reviore, La terre mourra ; la vegétation mourre ; olle mourra , andi que les hommes qui d'en nourrissent ; le sol qui les produit mourra, La terre mourra, la Terre Finisa; elle finiza pour ne plus zenaitre. Horna report : Faites comme vous voudrez ; moi je ferri revivre la Lune. Et ce que pegsedait Hima continua d'etre ; a que popridait Faton perit et l'asure dut mouro.

OCÉANIE EDITION BY JOHN MILLER

ba Noa

The Tahiti Journal of Paul Gauguin

Daul (Qauguin

TRANSLATED BY O.F. THEIS

CHRONICLE BOOKS SAN FRANCISCO This Chronicle Books LLC edition published in 2005. Copyright ©1994 by John Miller. All rights reserved. No part of this book may be reproduced in any form without written permission from the publisher.

ISBN 0-8118-4841-8

The Library of Congress has cataloged the previous edition as follows: Gauguin, Paul, 1848–1903

[Noa Noa. English]

Noa Noa/Paul Gauguin; translated by O.F. Theis. - Special oceanie ed./by John Miller

p. cm.

Originally published : New York : Greenberg, 1919.

ISBN 0-8118-0366-x

1. Gauguin, Paul, 1848–1903 – Diaries. 2. Painters – France – Diaries. 3. Tahiti. I. Miller, John. II. Title. ND553.G27A2 1994

759.4-dc20

[B]

93-7166 CIP

Manufactured in China.

Editing and design by John Miller, Big Fish Books Composition by Jennifer Petersen, Big Fish Books Cover Image: *Noa Noa* by Paul Gauguin. From 'Noa Noa Suite.' Rosenwald Collection ©1992 National Gallery of Art, Washington.

> Distributed in Canada by Raincoast Books 9050 Shaughnessy Street, Vancouver, B.C. V6P 6EP

> > 10 9 8 7 6 5 4 3 2 1

Chronicle Books, LLC 85 Second Street San Francisco, CA 94105 www.chroniclebooks.com

R

Masti tau le ori ori Atou té marama ura toura Ja hina pohé a toura Ja Téfatou o té taata.

"I have come to an unalterable decision to go and live forever in Polynesia. Then I can end my days in peace and freedom, without thoughts of to-morrow and this eternal struggle against idiots."

-PAUL GAUGUIN, October 1894

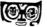

SO OFF HE WENT. To live out his days in paradise, painting and strolling among palms. Well, it didn't quite work out that way, but the journals of this Tahitian Odyssey made for quite a page-turner. The steamy manuscript, which he titled *Noa Noa* (fragrant fragrant), was a bit much for stuffy 1900 Europe—so the painter was forced to publish it himself. Tragically, this meant the exclusion of his suite of ten woodcuts, created expressly for the book. Now this special Oceanie Edition reunites the journals with the original etchings—just as Gauguin intended. We've also included several pages from the sketchbooks that eventually became *Noa Noa*. Welcome to Paradise!

-JM

INTRODUCTION

W. Somerset Maugham

IME PASSED. I had

long had it in mind to write a novel founded on the life of Paul Gauguin, and I went to Tahiti in the hope of finding people who had known him and whom I could induce to give me some useful information. I discovered presently that somewhere in the bush there was a hut where Gauguin, being ill, had spent some time, and during his convalescence had painted. I hired a car, and with a companion, drove about till my driver sighted the hut. I got out and walked along a narrow path till I came to it. Half a dozen children were playing on the stoop. A man, presumably their father, strolled out and when I told him what I wanted to see, asked me to come in. There were three doors; the lower part of each was of wooden panels and the upper panes of glass held together by strips of wood. The man told me that Gauguin had painted three pictures on the glass panes. The children had scratched away the painting on two of the doors and were just starting on the third. It represented Eve, nude, with the apple in her hand. . . . I asked the man if he would sell it. "I should have to buy a new door," he said. "How much would that cost?" I asked him. "Two hundred francs," he answered. I said I would give him that and he took it with pleasure. We unscrewed the door and my companion carried it to the car and drove back to Papeete. In the evening another man came to see me and said the door was half his. He asked me for two hundred francs more, which I gladly gave him. I had the wooden panel sawn off the frame and, taking all possible precautions, brought the panelled glass panes to New York and finally to France.

I have it in my writing-room.

(1962)

24 Soeurs d'aller la voir pendant qu'il remonterait à leur demeure, au sommet du Saïa. En approchant les Deesses la saluerent, l'averent sa baaute, et lui dirent qu'elles venaient d' Avanan District Le Bora Bora et qu'elles avaient un frère qui dégirait s'union à cle Vair aumati (c'était le nom de la jeune

file, examinant are attention les étrangers leur det . Vous n'étes pourt d'Avanau . Mais N'importe Si votre frère est Arii (chef) jeune et Beau il paut veun et Vairoumate Sera Sa femme. Téouri et Oaasa remontarent augitot au Paia pour faire connaître le régultat de leur demarche, à leur frère qui replacant le Anoua noua descendit à Vaitape . La il fut bien recu pan Son amante qui avait dresse un Fata charge de fruits et une couche formée des étoffes les plus riches et des nattes les plus fines.

NOA NOA (Fragrant, Fragrant)

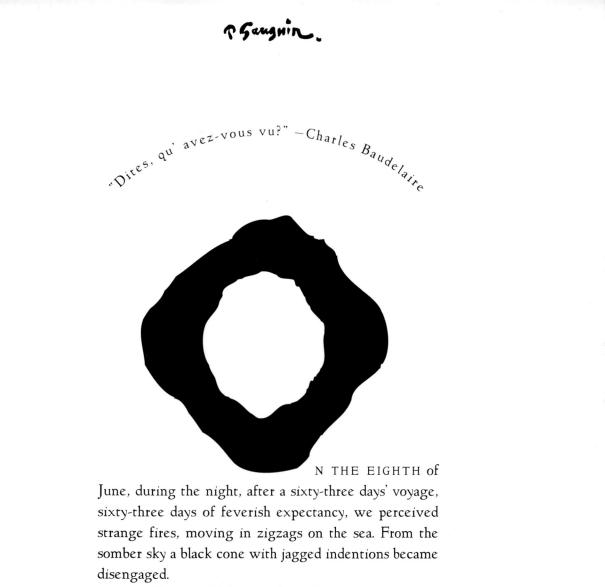

We turned Morea and had Tahiti before us.

of Gaughin

Several hours later dawn appeared, and we gently approached the reefs, entered the channel, and anchored without accidents in the roadstead.

The first view of this part of the island discloses nothing very extraordinary; nothing, for instance, that could be compared with the magnificent bay of Rio de Janeiro.

It is the summit of a mountain submerged at the time of one of the ancient deluges. Only the very point rose above the waters. A family fled thither and founded a new race—and then the corals climbed up along it, surrounding the peak, and in the course of centuries builded a new land. It is still extending, but retains its original character of solitude and isolation, which is only accentuated by the immense expanse of the ocean.

Toward ten o'clock I made my formal call on the governor, the negro Lacascade, who received me as though I had been an important personage.

I owed this distinction to the mission with which the French government—I do not know why—had entrusted me. It was an *artistic* mission, it is true. But in the view of the negro, however, this word was only an official synonym for espionage, and I tried in vain to undeceive him. Every one about him shared this belief, and when I

of Gaugnin

said that I was receiving no pay for my mission no one would believe me.

Life at Papeete soon became a burden.

It was Europe—the Europe which I had thought to shake off—and that under the aggravating circumstances of colonial snobbism, and the imitation, grotesque even to the point of caricature, of our customs, fashions, vices, and absurdities of civilization.

Was I to have made this far journey, only to find the very thing which I had fled?

Nevertheless, there was a public event which interested me.

At the time King Pomare was mortally ill, and the end was daily expected. Little by little the city had assumed a singular aspect.

All the Europeans, merchants, functionaries, officers, and soldiers, laughed and sang on the streets as usual, while the natives with grave mien and lowered voices held converse among themselves in the neighborhood of the palace. In the roadstead there was an abnormal movement of orange sails on the blue sea, and often the line of reefs shone in a sudden silvery gleam under the sun. The natives of neighboring islands were

10 Il les presse, les presse encore; mais ces Matienes ne veulent pas s'unin . Abors de sa main droite il lance les sept cieux pour en formen la première base, et la lumière est creée; l'Obscurité n'esciste plus - Cout se voit; l'interieur de l'univers brille, Le Dieu reste zavi en extase à la vue de l'immensité. L'unnobilité a cesse; le nouvement existe. La fonction des messagers est remplie; L'Orateur a rempli sa mission ; les pivots sout fixes ; les rochers sont en place ; les Sables Sont poses, Les Cieux tournent, les Cieux se sont élèrés ; la men remplit des profondeurs; l'illnivers est cree .,,

of Gaugnin

hastening hither to attend at the last moments of their king, and at the definite taking possession of their empire by France.

By signs from above they had had report of this, for whenever a king was about to die the mountains in certain places became covered with dark spots at the setting of the sun.

The king died, and lay in state in the palace in the uniform of an admiral.

There I saw the queen, Maraü —such was her name—decorating the royal hall with flowers and materials. When the director of public works asked my advice about the *artistic* arrangement of the funeral, I pointed out the queen to him. With the beautiful instinct of her race she dispersed grace everywhere about her, and made everything she touched a work of art.

I understood her only imperfectly at this first meeting. Both the human beings and the objects were so different from those I had desired, that I was disappointed. I was disgusted by all this European triviality. I had disembarked too recently yet to distinguish how much of nationality, fundamental realness, and primitive beauty still remained in this conquered race beneath the artificial

7 Gaugnin

and meretricious veneer of our importations. I was still in a manner blind. I saw in this queen, already somewhat mature in years, only a commonplace stout woman with traces of noble beauty. When I saw her again later, I revised my first judgment. I fell under the spell of her "Maori charm." Notwithstanding all the intermixture, the Tahitian "type was still very pure in her. And then the memory of her ancestor, the great chief Tati, gave her as well as her brother and all her family an appearance of truly imposing grandeur. She had the majestic sculptural form of her race, ample and at the same time gracious. The arms were like the two columns of a temple, simple, straight; and the whole bodily form with the long horizontal line of the shoulder, and the vast height terminating above in a point, inevitably made me think of the Triangle of the Trinity. In her eyes there sometimes burned something like a vague presentiment of passions which flared up suddenly and set aflame all the life round about. Perhaps, it is thus that the island itself once rose from the ocean, and that the plants upon it burst into flower under the first ray of the sun....

All the Tahitians dressed in black, and for two days they sang dirges of grief and laments for the dead. It

of Gaughin

seemed to me that I was listening to the Sonata Pathétique.

Then came the day of the funeral.

At ten in the morning they left the palace. The troops and the authorities were in white helmet and black dress-coat, the natives in their mourning costume. All the districts marched in order, and the leader of each one bore a French flag.

At Aruë they halted. There an indescribable monument rises—a formless mass of coral stones bound together by cement. It forms a painful contrast with the natural decorative beauty of vegetation and atmosphere.

Lacascade pronounced a discourse of conventional pattern, which an interpreter translated for the benefit of the Frenchmen present. Then the Protestant clergyman delivered a sermon to which Tati, the brother of the queen, responded. That was all. They left; the functionaries crowded into the carriages. It reminded one somewhat of a "return from the races."

In the confusion on the way the indifference of the French set the key, and the people, since a number of days so grave, recovered their gayety. The *vahinas* again took the arms of their *tanés*, chattered actively, and undu-

of Gaughin

lated their hips while their strong bare feet stirred up heavily the dust of the road.

Close to the river Fatü, there was a general scattering. Concealed among the stones the women crouched here and there in the water with their skirts raised to waist, cooling their haunches and legs tired from the march and the heat. Thus cleansed with the bosom erect and with the two shells covering the breasts rising in points under the muslin of the corsage, they again took up the way to Papeete. They had the grace and elasticity of healthy young animals. A mingled perfume, half animal, half vegetable emanated from them; the perfume of their blood and of the gardenias—*tiare*—which all wore in their hair.

"*Téiné merahi noa noa* (now very fragrant)," they said.

o Gaughin

HE PRINCESS ENTERED

my chamber where I lay, half-ill on the bed, dressed only in a *paréo*.¹ What a dress in which to receive a woman of rank!

"*Ia orana* (I greet thee), Gauguin," she said. "Thou art ill, I have come to look after thee."

"And what is your name?"

"Vaïtüa."

Vaïtüa was a real princess, if such still exist in this country, where Europeans have reduced everything to their own level. In fact, however, she had come as a simple ordinary mortal in a black dress, with bare feet, and a fragrant flower behind the ear. She was in mourning for King Pomare, whose niece she was. Her father, Tamatoa, in spite of the inevitable contacts with officers and functionaries, in spite of the receptions at the house of the admiral, had never desired to be anything other than a royal Maori. He was a gigantic brawler in moments of wrath, and on evenings of feasting a famous carouser. He was dead. Vaïtüa, according to report, was very like him.

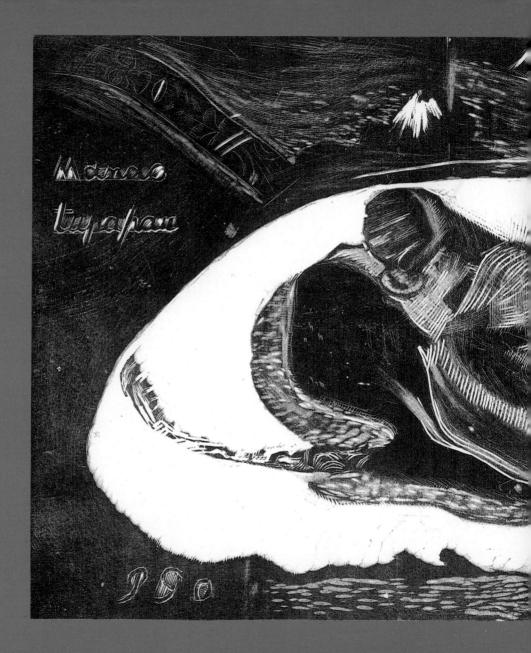

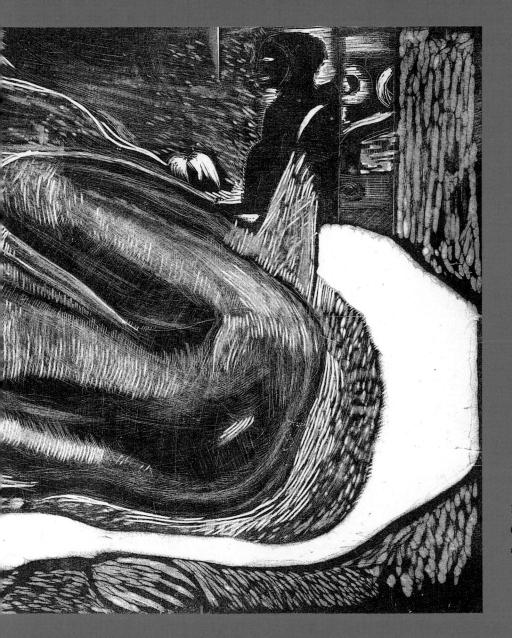

MANAO TUPAPAU (She Is Haunted by a Spirit)

O Gaughin.

With the insolence of a European only recently landed on the island in his white helmet, I looked with a skeptical smile on the lips at this fallen princess. But I wanted to be polite.

"It is very kind of you to have come, Vaïtüa. Shall we drink an absinthe together?"

I pointed with the finger to a bottle, which I had just bought, standing on the ground in a corner of the room.

Showing neither displeasure nor eagerness she went to the place indicated, and bent down to pick up the bottle. In this movement her slight, transparent dress stretched taut over her loins—loins to bear a world. Oh, surely, she was a princess! Her ancestors? Giants proud and brave. Her strong, proud, wild head was firmly planted on her wide shoulders. At first I saw in her only the jaws of a cannibal, the teeth ready to rend, the lurking look of a cruel and cunning animal, and found her, in spite of her beautiful and noble forehead, very ugly.

I hoped it wouldn't occur to her to sit down on my bed! So feeble a piece of furniture would never support both of us....

It is exactly what she did.

of Gaugnin

The bed creaked, but it held out.

In drinking we exchanged a few words. The conversation, however, did not want to become animated. It finally lagged entirely, and silence reigned.

I observed the princess secretly, and she looked at me out of a corner of the eye. Time passed, and the bottle gradually emptied. Vaïtüa was a brave drinker.

She rolls a Tahitian cigarette and stretches out on the bed to smoke. Her feet with a mechanical gesture continually caress the wood of the foot-end. Her expression becomes gentler, it visibly softens, her eyes shine, and a regular hissing sound escapes from her lips. I imagine that I am listening to a purring cat that is meditating on some bloody sensuality.

As I am changeable, I find her now very beautiful, and when she said to me with a throbbing voice, "You are nice," a great trouble fell upon me. Truly the princess was delicious....

Doubtless in order to please me, she began to recite a fable, one of La Fontaine's, *The Cricket and the Ants*—a memory of her childhood days with the sisters who had taught her.

The cigarette was entirely alight.

7 Gaugnin

"Do you know, Gauguin," said the princess in rising, "I do not like your La Fontaine."

"What? Our good La Fontaine?"

"Perhaps, he is *good*, but his morals are ugly. The ants . . ." (and her mouth expressed disgust). "Ah, the crickets, yes. To sing, to sing, always to sing!"

And proudly without looking at me, the shining eyes fixed upon the far distance, she added,

"How beautiful our realm was when nothing was sold there! All the year through the people sang. . . . To sing always, always to give! . . ."

And she left.

I put my head back on the pillow, and for a long time I was caressed by the memory of the syllables:

"Ia orana, Gauguin."

THIS EPISODE WHICH I associate in my memory with the death of King Pomare left deeper traces than that event itself and the public ceremonies.

The inhabitants of Papeete, both native and white,

of Gaughin.

soon forgot the dead king. Those who had come from the neighboring islands to take part in the royal obsequies left; again thousands of orange sails crossed the blue sea, then everything returned to the customary routine.

It was only one king less.

With him disappeared the last vestiges of ancient traditions. With him Maori history closed. It was an end. Civilization, alas!—soldiers, trade, officialdom—triumphed.

A profound sadness took possession of me. The dream which had brought me to Tahiti was brutally disappointed by the actuality. It was the Tahiti of former times which I loved. That of the present filled me with horror.

In view of the persistent physical beauty of the race, it seemed unbelievable that all its ancient grandeur, its personal and natural customs, its beliefs, and its legends had disappeared. But how was I, all by myself, to find the traces of this past if any such traces remained? How was I to recognize them without guidance? How to relight the fire the very ashes of which are scattered?

However depressed I may be I am not in the habit of giving up a project without having tried everything, even the "impossible," to gain my end.

My resolve was quickly taken. I would leave

of Gaughin

Papeete, and withdraw from this European center.

I felt that in living intimately with the natives in the wilderness I would by patience gradually gain the confidence of the Maoris and come to *know* them.

And one morning I set out in a carriage which one of the officers had graciously put at my disposal in search of "my hut."

My vahina, Titi by name, accompanied me. She was of mixed English and Tahitian blood, and spoke some French. She had put on her very best dress for the journey. The tiaré was behind the ear; her hat of reeds was decorated above with ribbon, straw flowers, and a garniture of orange-colored shells, and her long black hair fell loose over the shoulders. She was proud to be in a carriage, proud to be so elegant, proud to be the vahina of a man whom she believed important and rich. She was really handsome, and there was nothing ridiculous in her pride, for the majestic mien is becoming to this race. In memory of its long feudal history and its endless line of powerful chiefs it retains its superb strain of pride. I knew very well that her calculating love in the eyes of Parisians would not have had much more weight than the venial complaisance of a harlot. But the amorous passion of a

of Saughin.

Maori courtesan is something quite different from the passivity of a Parisian cocotte—something very different! There is a fire in her blood, which calls forth love as its essential nourishment; which exhales it like a fatal perfume. These eyes and this mouth cannot lie. Whether calculating or not, it is always love that speaks from them....

The journey was soon accomplished—a few bits of inconsequential conversation, a rich, monotonous country. On the right there was always the sea, the coralreefs and the sheets of water which sometimes scattered in spray when they came into too violent contact with the waves and the rocks. To the left was the wilderness with its perspective of great forests.

By noonday we had accomplished our forty-five kilometers, and had arrived at the district of Mataïea.

I made a search through the district and succeeded in finding a suitable enough hut, which the owner rented to me. He was building a new one near by where he intended to dwell.

On the next evening when we returned to Papeete, Titi asked me whether I wished her to accompany me.

O Gaugnin.

"Later, in a few days, when I have become settled," I said.

Titi had a terrible reputation at Papeete of having successively brought a number of lovers to their grave. But it was not this which made me put her aside. It was her half-white blood. In spite of traces of profoundly native and truly Maori characteristics, the many contacts had caused her to lose many of her distinctive racial "differences." I felt that she could not teach me any of the things I wished to know, that she had nothing to give of that special happiness which I sought.

I told myself, that in the country I would find that which I was seeking; it would only be necessary to choose.

(Gaugnin

sea; on the other, the mountain, a deeply fissured mountain; an enormous cleft closed by a huge mango leaning against the rocks.

Between the mountain and the sea stood my hut, made of the wood of bourao tree. Close to the hut in which I dwelled was another, the *faré amu* (hut for eating).

IT IS MORNING.

On the sea close to the strand I see a pirogue, and in the pirogue a half-naked woman. On the shore is a man, also undressed. Beside the man is a diseased cocoanut-tree with shriveled leaves. It resembles a huge parrot with golden tails hanging down, and holding in his claws a huge cluster of cocoanuts. With a harmonious gesture the man raises a heavy ax in his two hands. It leaves above a blue impression against the silvery sky, and below a rosy incision in the dead tree, where for an

o Gaughin

inflammatory moment the ardor stored up day by day throughout centuries will come to life again.

On the purple soil long serpentine leaves of a metallic yellow make me think of a mysterious sacred writing of the ancient Orient. They distinctly form the sacred word of Oceanian origin, ATUA (God), the Taäta or Takata or Tathagata, who ruled throughout all the Indies. And there came to my mind like a mystic counsel, in harmony with my beautiful solitude and my beautiful poverty the words of the sage:

In the eyes of Tathagata, the magnificence and splendor of kings and their ministers are no more than spittle and dust;

In his eyes purity and impurity are like the dance of the six nagas;

In his eyes the seeking for the sight of the Buddha is like unto flowers.

In the pirogue the woman was putting some nets in order.

The blue line of the sea was frequently broken by the green of the wave-crests falling on the breakwater of coral.

Ei des sables et rivages au terres mouvautes. lie des roches et parties solides. Sout nés après. Evenements de la muit, de l'Obscurité. Evenements du jour ou de la Vie. L'Allen at le Retour Verin Flux at Reflux. Le Donnen et le Recevoir du Plaisin.

of Saughin.

Ð

IT IS EVENING.

I have gone to smoke a cigarette on the sands at the edge of the sea.

The sun, rapidly sinking on the horizon, is already half concealed behind the island of Morea which lay to my right. The conflict of light made the mountains stand out sharply and strangely in black against the violet glow of the sky. They were like ancient battlemented castles.

Is it any wonder that before this natural architecture visions of feudal magnificence pursue me? The summit, over there, has the form of a gigantic helmet-crest. The billows around it, which sound like the noise of an immense crowd, will never reach it. Amid the splendor of the ruins the crest stands alone, a protector or witness, a neighbor of the heavens. I felt a secret look plunge from the head up there into waters which had once engulfed the sinful race of the living, and in the vast fissure which might have been the mouth I felt the hovering of a smile of irony or pity over the waters where the past sleeps....

Night falls quickly. Morea sleeps.

of Gaughin

ing to know the silence of a Tahitian night.

In this silence I hear nothing except the beating of my heart.

But the rays of the moon play through the bamboo reeds, standing equidistant from each other before my hut, and reach even to my bed. And these regular intervals of light suggest a musical instrument to me—the reed-pipe of the ancients, which was familiar to the Maori, and is called *vivo* by them. The moon and the bamboo reeds made it assume an exaggerated form—an instrument that remained silent throughout the day, but that at night by grace of the moon calls forth in the memory of the dreamer well-loved melodies. Under this music I fell asleep.

Between me and the sky there was nothing except the high frail roof of pandanus leaves, where the lizards have their nests.

I am far, far away from the prisons that European houses are.

O Gaughin.

A Maori hut does not separate man from life, from space, from the infinite....

In the meantime I felt myself very lonely here.

The inhabitants of the district and I mutually watched each other, and the distance between us remained the same.

By the second day I had exhausted my provisions. What to do? I had imagined that with money I would be able to find all that was necessary for life. I was deceived. Once beyond the threshold of the city, we must turn to Nature in order to live. She is rich, she is generous, she refuses to no one who will ask his share of her treasures of which she has inexhaustible reserves in the trees, in the mountains, in the sea. But one must know how to climb the tall trees, how to go into the mountains, in order to return weighed down with heavy booty. One must know how to catch fish, and how to dive to tear loose the shellfish so firmly attached to stones at the bottom of the sea. One must know how, one must be able to do things.

Here was I, a civilized man, distinctly inferior in these things to the savages. I envied them. I looked at their happy, peaceful life round about me, making no further effort than was essential for their daily needs, without the

of Gaugnin

least care about money. To whom were they to sell, when the gifts of Nature were within the reach of every one?

There I was sitting with empty stomach on the threshold of my hut, sadly considering my state, and thinking of the unforeseen, perhaps insurmountable, obstacles which Nature has created for her protection and placed between herself and him who comes from a civilized world, when I saw a native gesticulating and calling out something to me. The expressive gestures interpreted the words, and I understood that my neighbor was inviting me to dinner. With a shake of my head I declined. Then I reentered my hut, ashamed, I believe equally because charity had been offered me, and because I had refused it.

A few minutes later a little girl without saying anything left some cooked vegetables in front of my door, and also fruit wrapped neatly in green freshly picked leaves. I was hungry, and likewise without a word I accepted the gift.

A little later, the man passed in front of my hut, and, smiling, but without stopping, said in a questioning tone,

> *"Païa?*" I divined, "Are you contented?"

of Gaughin

This was the beginning of a reciprocal understanding between the savages and myself.

"Savages!" This word came involuntarily to my lips when I looked at these black beings with their cannibal-like teeth. However, I already had a glimpse of their genuine, their strange grace ... I remembered the little brown head with the placid eyes cast to the ground, which from under the clusters of large giromon leaves watched me one morning without my knowing it, and fled when my glance met hers....

As they were to me, so was I to them, an object for observation, a cause of astonishment—one to whom everything was new, one who was ignorant of everything. For I knew neither their language, nor their customs, not even the simplest, most necessary manipulations. As each one of them was a savage to me, so was I a savage to each one of them.

And which of us two was wrong?

I tried to work, making all kinds of notes and sketches.

But the landscape with its violent, pure colors dazzled and blinded me. I was always uncertain; I was seeking, seeking....

of Gaugnin

In the meantime, it was so simple to paint things as I saw them; to put without special calculation a red close to a blue. Golden figures in the brooks and on the seashore enchanted me. Why did I hesitate to put all this glory of the sun on my canvas?

Oh! the old European traditions! The timidities of expression of degenerate races!

In order to familiarize myself with the distinctive characteristics of the Tahitian face, I had wished for a long time to make a portrait of one of my neighbors, a young woman of pure Tahitian extraction.

One day she finally became emboldened enough to enter my hut, and to look at photographs of paintings which I had hung on one of the walls of my room. She regarded the *Olympia* for a long time and with special interest.

"What do you think of her?" I asked. I had learned a few Tahitian words during the two months since I had last spoken French.

My neighbor replied, "She is very beautiful!"

I smiled at this remark, and was touched by it. Had she then a sense of the beautiful? But what reply would the professors of the Academy of Fine Arts have made to this remark?

27

O Gaughin.

Then suddenly after a perceptible silence such as precedes the thinking out of a conclusion, she added,

"Is it your wife?"

"Yes."

I did not hesitate at this lie. I-the tané of the beautiful Olympia!

While she was curiously examining certain religious compositions of the Italian primitives, I hastened, without her noticing it, to sketch her portrait.

She saw it, and with a pout cried out abruptly, "*Aïta* (no)!" and fled.

An hour later she returned, dressed in a beautiful robe with the *tiaré* behind the ear. Was it coquetry? Was it the pleasure of consenting of her own free will after having refused? Or was it simply the universal attraction of the forbidden fruit which one denies one's self? Or more probably still, was it merely a caprice without any other motive, a pure caprice of the kind to which the Maoris are so given?

Without delay I began work, without hesitation and all of a fever. I was aware that on my skill as a painter would depend the physical and moral posses-

of Gaughin

sion of the model, that it would be like an implied, urgent, irresistible invitation.

She was not at all handsome according to our aesthetic rules.

She was beautiful.

All her traits combined in a Raphaelesque harmony by the meeting of curves. Her mouth had been modeled by a sculptor who knew how to put into a single mobile line a mingling of all joy and all suffering.

I worked in haste and passionately, for I knew that the consent had not yet been definitely gained. I trembled to read certain things in these large eyes—fear and the desire for the unknown, the melancholy of bitter experience which lies at the root of all pleasure, the *involuntary and sovereign* feeling of being mistress of herself. Such creatures seem to submit to us when they give themselves to us; yet it is only to themselves that they submit. In them resides a force which has in it something superhuman—or perhaps something divinely animal.

ונרימין ניירוין יוי פר Ru separa les cieux et la terre. Mahour tira la terre du fond des eaux regla le cours du soliil de facon que le jour et la nuit soient de meme durée Rome fit gouflew les eaux de l'Ocean, brisa la terre continent et ne laissa que les îles actuelles. Fanoura - Sa tête touchait aux nues, ses pieds au fond de la men. Fanoura at Fatouhoui deux geauts allerent enjemble à Eiva terre inconnue combattre le monstre (bouaa hai taata) le cochon qui dévorait les hommer

Hiro Dien des volours, faisait avec ses duigts des 47 trous dans les rochers, Il délivra une vierge retenue dans un lieu enchanté, gasdée par des geans . Il arracha D'une Seule main les arbres qui tenaient le lieu enchanté. Le charme fut einture Rouge (Symbole de divinité et du feu.

(Gaughin

OW I WORK more

freely, better.

But my solitude still disturbs me.

Indeed, I saw in the district young women and young girls, tranquil of eye, pure Tahitians, some of whom would perhaps gladly have shared my life.— However, I did not dare approach them. They actually made me timid with their sure look, their dignity of being, and their pride of gait.

All, indeed, wish to be "taken," literally, brutally taken (*Maü*, to seize), without a single word. All have the secret desire for violence, because this act of authority on the part of the male leaves to the woman-will its full share of irresponsibility. For in this way she has not given her consent for the beginning of a permanent love. It is possible that there is a deeper meaning in this violence which at first sight seems so revolting. It is possible also that it has a savage sort of charm. I pondered the matter, indeed, but I did not dare.

Then, too, some were said to be ill, ill with that

of Gaugnin.

malady which Europeans confer upon savages, doubtless as the first degree of their initiation into civilized life....

And when the older among them said to me, pointing to one of them, "*Maü téra* (take that one)," I had neither the necessary audacity nor confidence.

> I let Titi know I would be pleased to take her again. She came at once.

The experiment succeeded badly. By the boredom which I felt in the company of this woman so used to the banal luxury of officials, I was able to measure the real progress which had already been made toward the beautiful life of the savages.

> After a few weeks Titi and I separated forever. Again I was alone.

MY NEIGHBORS HAVE become my friends. I dress like them, and partake of the same food as they. When I am not working, I share their life of indolence and joy, across which sometimes pass sudden moments of gravity.

In the evening they unite in groups at the foot of the tufted bushes which overtop the disheveled heads of

7 Gaughin

the cocoanut-trees, or men and women, old men and children intermingle. Some are from Tahiti, others from the Tongas, and still others from the Marquesas. The dull tones of their bodies form a lovely harmony with the velvet of the foliage. From their coppery breasts trembling melodies arise, and are faintly thrown back from the wrinkled trunks of the cocoanut-trees. They are the Tahitian songs, the *iménés*.

A woman begins. Her voice rises like the flight of a bird, and from the first note reaches even to the highest of the scale; then by strong modulations it lowers again and remounts and finally soars, while the voices of the other women about her, so to speak, take flight in their turn, and faithfully follow and accompany her. Finally all the men in a single guttural and barbarous cry close the song in a tonic chord.

Sometimes in order to sing or converse they assemble in a sort of communal hut. They always begin with a prayer. An old man first recites it conscientiously, and then all those present take it up like a refrain. Then they sing, or tell humorous stories. The theme of these recitals is very tenuous, almost unseizable. It is the details, broidered into the woof and made subtle by

of Gaugnin

their very naïveté, which amuse them.

More rarely, they discourse on serious questions or put forth wise proposals.

One evening I heard, not without surprise, the following:

"In our village," an old man said, "we see here and there houses which have fallen to ruin and shattered walls and rotting, half-open roofs through which the water penetrates when by chance it rains. Why? Every one in the world has the right to shelter. There is lacking neither of wood, nor of leaves wherewith to build the roofs. I propose that we work in common and build spacious and solid huts in place of those which have become uninhabitable. Let us all give a hand to it in turn."

All those present without exception applauded him.—He had said well!

And the motion of the old man was unanimously adopted. "This is a prudent and good people," I said myself on my return home that evening.

But the next day when I went to obtain information about the beginning of the work determined upon the evening before, I perceived that no one was any longer giving it a thought. The daily life had again

of Gaughin

taken its usual course, and the huts which the wise counselor had designated remained in their former ruined state.

To my questions they replied with evasive smiles.

Yet the contraction of the brows drew significant lines on these vast dreaming foreheads.

I withdrew with my thoughts full of confusion, and yet with the feeling that I had received an important lesson from my savages. Certainly they did right in applauding the proposal of the old man; perhaps they were equally justified in not carrying out the adopted resolution.

Why work? The gods are there to lavish upon the faithful the good gifts of nature.

"To-morrow?"

"Perhaps!"

And whatever may happen the sun will rise tomorrow as it rose to-day, beneficent and serene.

Is it heedlessness, frivolity, or variableness? Or is it—who knows—the very deepest of philosophy? Beware of luxury! Beware of acquiring the taste and need for it, under the pretext of providing for the morrow....

Life each day became better.

I understand the Maori tongue well enough by

of Gaughin

now, and it will not be long before I speak it without difficulty.

My neighbors-three of them quite close by, and many more at varying distances from each other-look upon me as one of them.

Under the continual contact with the pebbles my feet have become hardened and used to the ground. My body, almost constantly nude, no longer suffers from the sun.

Civilization is falling from me little by little.

I am beginning to think simply, to feel only very little hatred for my neighbor—rather, to love him.

All the joys—animal and human—of a free life are mine. I have escaped everything that is artificial, conventional, customary. I am entering into the truth, into nature. Having the certitude of a succession of days like this present on, equally free and beautiful, peace descends on me. I develop normally and no longer occupy myself with useless vanities.

I have won a friend.

He came to me of his own accord, and I feel sure here that in his coming to me there was no element of self-interest.

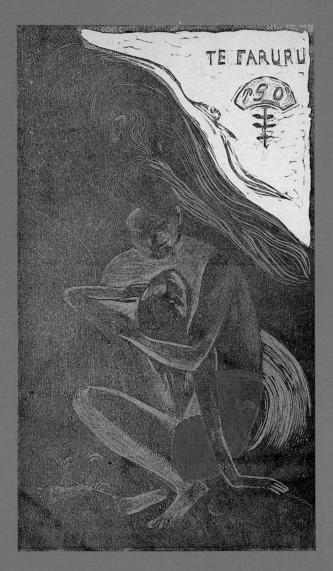

TE FARURU (They Are Making Love Here) He is one of my neighbors, a very simple and handsome young fellow.

My colored pictures and carvings in wood aroused his curiosity; my replies to his questions have instructed him. Not a day passes that he does not come to watch me paint or carve...

Even after this long time I still take pleasure in remembering the *true* and *real* emotions in this *true* and *real* nature.

In the evening when I rested from my day's work, we talked. In his character of a wild young savage he asked many questions about European matters, particularly about the things of love, and more than once his questions embarrassed me.

But his replies were even more naïve than his questions.

One day I put my tools in his hand and a piece of wood; I wanted him to try to carve. Nonplussed, he looked at me at first in silence, and then returned the wood and tools to me, saying with entire simplicity and sincerity, that I was not like the others, that I could do things which other men were incapable of doing, and that I was useful to others.

O Gaughin.

I indeed believe Totefa is the first human being in the world who used such words toward me. It was the language of a savage or of a child, for one must be either one of these—must one not?—to imagine that an artist might be a useful human being.

It happened once that I had need of rosewood for my carving. I wanted a large strong trunk, and I consulted Totefa.

"We have to go into the mountains," he told me. "I know a certain spot where there are several beautiful trees. If you wish it I will lead you. We can then fell the tree which pleases you and together carry it here."

We set out early in the morning.

The footpaths in Tahiti are rather difficult for a European, and "to go into the mountains" demands even of the natives a degree of effort which they do not care to undertake unnecessarily.

Between two mountains, two high and steep walls of basalt, which it is impossible to ascend, there yawns a fissure in which the water winds among rocks. These blocks have been loosened from the flank of the mountain by infiltrations in order to form a passageway for a spring. The spring grew into a brook, which has

of Gaughin

thrust at them and jolted them, and then moved them a little further. Later the brook when it became a torrent took them up, rolled them over and over, and carried them even to the sea. On each side of this brook, frequently interrupted by cascades, there is a sort of path. It leads through a confusion of trees—breadfruit, ironwood, pandanus, bouraos, cocoanut, hibiscus, guava, giant-ferns. It is a mad vegetation, growing always wilder, more entangled, denser, until, as we ascend toward the center of the island, it has become an almost impenetrable thicket.

Both of us went naked, the white and blue *paréo* around the loins, hatchet in hand. Countless times we crossed the brook for the sake of a short-cut. My guide seemed to follow the trail by smell rather than by sight, for the ground was covered by a splendid confusion of plants, leaves, and flowers which wholly took possession of space.

The silence was absolute but for the plaintive wailing of the water among the rocks. It was a monotonous wail, a plaint so soft and low that it seemed an accompaniment of the silence.

And in this forest, this solitude, this silence were we two-he, a very young man, and I, almost an old man

R Gaugnin

from whose soul many illusions had fallen and whose body was tired from countless efforts, upon whom lay the long and fatal heritage of the vices of a morally and physically corrupt society.

With the suppleness of an animal and the graceful litheness of an androgyne he walked a few paces in advance of me. And it seemed to me that I saw incarnated in him, palpitating and living, all the magnificent plantlife which surrounded us. From in him, through him there became disengaged and emanated a powerful perfume of beauty.

Was it really a human being walking there ahead of me? Was it the naive friend by whose combined simplicity and complexity I had been so attracted? Was it not rather the Forest itself, the living Forest, without sex and yet alluring?

Among peoples that go naked, as among animals, the difference between the sexes is less accentuated than in our climates. Thanks to our cinctures and corsets we have succeeded in making an artificial being out of woman. She is an anomaly, and Nature herself, obedient to the laws of heredity, aids us in complicating and enervating her. We carefully keep her in a state of nervous

of Gaughin.

weakness and muscular inferiority, and in guarding her from fatigue, we take away from her possibilities of development. Thus modeled on a bizarre ideal of slenderness to which, strangely enough, we continue to adhere, our women having nothing in common with us, and this, perhaps, may not be without grave moral and social disadvantages.

On Tahiti the breezes from forest and sea strengthen the lungs, they broaden the shoulders and hips. Neither men nor women are sheltered from the rays of the sun nor the pebbles of the sea-shore. Together they engage in the same tasks with the same activity or the same indolence. There is something virile in the women and something feminine in the men.

This similarity of the sexes makes their relations the easier. Their continual state of nakedness has kept their minds free from the dangerous pre-occupation with the "mystery" and from the excessive stress which among civilized people is laid upon the "happy accident" and the clandestine and sadistic colors of love. It has given their manners a natural innocence, a perfect purity. Man and woman are comrades, friends rather than lovers, dwelling together almost without cease, in pain as in pleasure, and

of Gaughin

even the very idea of vice is unknown to them.

In spite of all this lessening in sexual differences, why was it that there suddenly rose in the soul of a member of an old civilization, a horrible thought? Why, in all this drunkenness of lights and perfumes with its enchantment of newness and unknown mystery?

The fever throbbed in my temples and my knees shook.

But we were at the end of the trail. In order to cross the brook my companion turned, and in this movement showed himself full-face. The androgyne had disappeared. It was an actual young man walking ahead of me. His calm eyes had the limpid clearness of waters.

Peace forthwith fell upon me again.

We made a moment's halt. I felt an infinite joy, a joy of the spirit rather than of the senses, as I plunged into the fresh water of the brook.

"Toë, toë (it is cold)," said Jotefa.

"Oh, no!" I replied.

This exclamation seemed to me also a fitting conclusion to the struggle which I had just fought out within myself against the corruption of an entire civilization. It

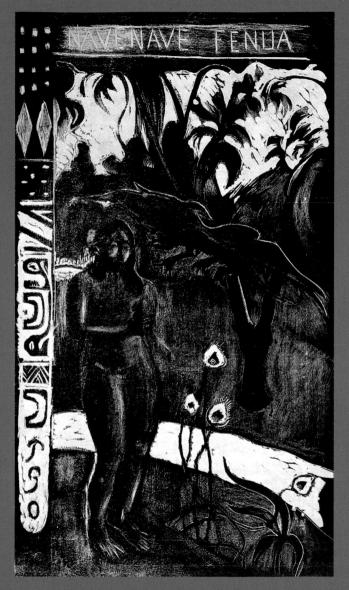

NAVE NAVE FENUA (Delightful Land)[.]

Gaughin

was the end in the battle of a soul that had chosen between truth and untruth. It awakened loud echoes in the forest. And I said to myself that Nature had seen me struggle, had heard me, and understood me, for now she replied with her clear voice to my cry of victory that she was willing after the ordeal to receive me as one of her children.

We took up our way again. I plunged eagerly and passionately into the wilderness, as if in the hope of thus penetrating into the very heart of this Nature, powerful and maternal, there to blend with her living elements.

With tranquil eyes and ever uniform pace my companion went on. He was wholly without suspicion; I alone was bearing the burden of an evil conscience.

We arrived at our destination.

The steep sides of the mountain had by degrees spread out, and behind a dense curtain of trees, there extended a sort of plateau, well-concealed. Jotefa, however, knew the place, and with astonishing sureness led me thither. A dozen rosewood trees extended their vast branches. We attacked the finest of these with the ax. We had to sacrifice the entire tree to obtain a branch suitable for my project.

I struck out with joy. My hands became stained

of Gaughin.

with blood in my wild rage, my intense joy of satiating within me, I know not what divine brutality. It was not the tree I was striking, it was not it which I sought to overcome. And yet gladly would I have heard the sound of my ax against other trunks when this one was already lying on the ground.

And here is what my ax seemed to say to me in the cadence of its sounding blows:

Strike down to the root the forest entire! Destroy all the forest of evil, Whose seeds were once sowed within thee by the breathings of death! Destroy in thee all love of the self! Destroy and tear out all evil, as in the autumn we cut with the hand the flower of the lotus.

7 Saughin

YES, WHOLLY DESTROYED, finished, dead, is from now on the old civilization within me. I was reborn; or rather another man, purer and stronger, came to life within me.

This cruel assault was the supreme farewell to civilization, to evil. This last evidence of the depraved instincts which sleep at the bottom of all decadent souls, by very contrast exalted the healthy simplicity of the life at which I had already made a beginning into a feeling of inexpressible happiness. By the trial within my soul mastery had been won. Avidly I inhaled the splendid purity of the light. I was, indeed, a new man; from now on I was a true savage, a real Maori.

Jotefa and I returned to Mateïea, carefully and peacefully bearing our heavy load of rosewood—noa, noa!

The sun had not yet set when, very tired out, we arrived before my hut.

Jotefa said to me,"Paia."

"Yes!" I replied.

And from the bottom of my heart I repeated this "yes" to myself.

of Gaughin.

I have never made a single cut with the knife into this branch of rosewood, that I did not each time more powerfully breathe in the perfume of victory and rejuvenation: *noa, noa!*

THROUGH THE VALLEY of Punaru, a huge fissure which divides Tahiti into two parts, one reaches the plateau of Tamanoü. From there one can see the diadem, Orofena and Aroraï, which forms the center of the island.

They had often spoken to me of it as a place of miracles, and I had contrived the plan of going and spending several days there alone.

"But what will you do during the night?"

"You will be tormented by the Tupapaüs!"

"It is not wise to disturb the spirits of the mountain...."

"You must be mad!"

Probably I was, but as the result of this anxious solicitude of my Tahitian friends my curiosity was all the more aroused.

O Gaughin.

Before dawn, one night, I set out for Aroraï. For almost two hours it was possible to follow a path on the edge of the Punaru river. But then I was repeatedly forced to cross the river. On both sides the walls of the mountain rose straight up. They jutted out even to the middle of the water, supported on huge cubes of stone as if on buttresses.

Finally, I was compelled to continue my way in the middle of the river. The water went up to my knees, and sometimes even to the shoulders.

The sun, even in broad daylight, scarcely pierced between the two walls which from below seemed to me of astonishing height and very close together at the top. At midday I distinguished the twinkling of stars in the brilliant blue of the sky.

Toward five o'clock, as the day was declining, I began to wonder where I was to spend the night, when I noticed to the right an almost flat space of several acres. It was covered with a confusion of ferns, wild bananas, and bouraos. By good fortune I found several ripe bananas. Quickly I built a wood-fire to cook them. They constituted my dinner.

Then I lay down to sleep as well as I might, at the

of Gaugnin

foot of a tree on the low branches with which I had intertwined banana leaves to protect me in case of rain.

It was cold, and the wading in the water left me chilled through and through.

I did not sleep well.

But I knew that dawn would not delay long and that I had nothing to fear from either man or beast. There are neither carnivores nor reptiles on Tahiti. The only "wild game" on the island are the pigs which have escaped into the forest, where they have multiplied and become entirely wild. The most I had to fear was that they might come, and rub off the skin of my legs. For that reason I kept the cord of my hatchet around my wrist.

The night was profound. It was impossible to distinguish anything, save a powdery phosphorescence close to my head which strangely perplexed me. I smiled when I thought of the Maori stories about the *Tupapauis*, the evil spirits which awaken with the darkness to trouble sleeping men. Their realm is in the heart of the mountain, which the forest surrounds with eternal shadows. There it swarms with them, and without cease their legions are increased by the spirits of those who have died.

Woe to him who will hazard into a place inhabited

40 O Réhoua é faus ité ama ama noui ia a tea a noho ité vahiné te Oura Tancipa fanaou aéra tana arii o té houi tazara ia matarii.

of Gaughin

by these demons! . . . And I had this audacity!

My dreams too were troubling enough.

Now, I know that the powdery luminosity emanated from a particular species of small fungus. They grew in most places on dead branches like those which I had used in building my fire.

On the following day, very early, I took up my way again.

The river became more and more irregular. It was now brook, now torrent, now waterfall. It wound about in a strangely capricious way, and sometimes seemed to flow back into itself. I was continually losing the path, and often had to advance swinging from branch to branch with the hands, scarcely touching the ground.

From the bottom of the water cray-fish of extraordinary shape looked at me as if to say, "What are you doing here?" And hundred-year-old eels fled at my approach.

Suddenly, at an abrupt turn, I saw a naked young girl leaning against a projecting rock. She was caressing it with both hands, rather than using it as a support. She was drinking from a spring which in silence trickled from a great height among the rocks.

of Gaughin

After she had finished drinking, she let go of the rock, caught the water in both hands, and let it run down between her breasts. Then, though I had not made the slightest sound, she lowered her head like a timid antelope which instinctively scents danger and peered toward the thicket where I remained motionless. My look did not meet hers. Scarcely had she seen me, than she plunged below the surface, uttering the word,

"Taehae (furious)."

Quickly I looked into the river-no one, nothing-only an enormous eel which wound in and out among the small stones at the bottom.

It was not without difficulty or fatigue that I finally approached Aroraï, the dreaded sacred mountain which formed the summit of the island.

It was evening, the moon was rising, and as I watched its soft lights gently enveloping the rugged brow of the mountain, I recalled the famous legend: "Paraü Hina Tefatou (Hina said to Tefatou)."

It was a very ancient legend which the young girls love to tell while sitting about in the evening, and according to them the event occurred on the very spot where I was.

of Gaughin.

And truly it seemed to me that I saw the scene now.

A powerful head of a god-man, the head of a hero upon whom Nature had conferred the proud consciousness of his strength, a magnificent face of a giant—at the ultimate lines of the horizon and as at the threshold of the world. A soft clinging woman gently touched the hair of God and spoke to him:

"Let man rise up again after he has died...."

And the angry but not cruel lips of the god opened to reply,

"Man shall die."

Gaughin

OR SOME TIME past I

had been growing restless. My work suffered under it.

It is true that I lacked many of the essential implements; it irritated me to be reduced to impotence in the face of artistic projects to which I had passionately given myself.

But it was joy most of all which I lacked.

It was several months since I had separated from Titi. For several months I had not heard the childish, melodious babble which flowed without cease from the *vahina*, always about the same things, always asking the same questions, and I always replying with the same stories.

This silence was not good for me.

I decided to leave, and undertake a voyage around the island. I had set no definite limits to it.

While I was making my preparations—a few light packages that might be needed on the way—and putting my studies in order, my neighbor and landlord, my friend Anani, watched me with unquiet eyes. After long hesitation, with gestures half-begun and left incomplete whose

of Gaugnin.

meaning was clear enough to me and at the same time amused and touched me, he finally decided to ask me whether I was intending to leave.

"No," I replied to him, "I am merely making a several days' excursion. I shall return."

He did not believe me, and began to cry.

His wife came and joined him and told me she liked me, that money was not required in order to live among them, and that some day, if I so wished, I could rest for always-there. She pointed to a burial mound, ornamented with small trees, close to the hut.

And suddenly a desire fell upon me to rest for always—*there*. At least for all eternity no one would ever disturb me there.

"You people of Europe," added the wife of Anani, "are strange. You come, you promise to remain, and when we have come to love you, you leave. To return, you say, but you never return."

"But I swear that it is my intention to return, *this time*. Later," (I did not dare to lie), "later, I shall see."

Finally they let me go.

of Gaughin

I LEFT THE road which follows the edge of the sea, and took up a narrow path leading through a dense thicket. This path led so far into the mountains that at the end of several hours I reached a little valley where the inhabitants still lived in the ancient Maori manner.

They are happy and undisturbed. They dream, they love, they sleep, they sing, they pray, and it seems that Christianity has not yet penetrated to this place. Before me I can clearly see the statues of their divinities, though actually they have long since disappeared; especially the statue of Hina, and the feasts in honor of the moon-goddess. The idol of a single block of stone measures ten feet from shoulder to shoulder and forty feet in height. On the head she wears in the manner of a hood a huge stone of reddish color. Around her they dance according to ancient rite, the *matamua*, and the *vivo* varies its notes from lightness and gayety to somberness and melancholy according to the color of the hour....

I continue my way.

At Taravao, the district farthest from Mataïea at the other extremity of the island, a gendarme lends me

of Gaugnin,

his horse, and I range along the east coast, which is little frequented by Europeans.

At Faone, a tiny district which precedes the more important one of Itia, I hear a native calling out to me,

"Halloa! Man who makes human beings!"—He knows that I am a painter.—"*Haëre maï ta maha* (come and eat with us)." This is the Tahitian formula of hospitality.

No persuasion is required, for the smile accompanying the invitation is engaging and gentle.

I dismount from the horse. My host takes the animal by the bridle and ties it to a branch, simply and skillfully, without a trace of servility.

Together we enter a hut where men and women are sitting together on the ground talking and smoking. Around them children play and prattle.

"Where are you going?" asked a beautiful Maori woman of about forty.

"I am going to Itia."

"What for?"

I do not know what idea flitted across my mind. Perhaps, I was only giving expression to the real purpose of my journey, which had hitherto been hidden even to myself.

"To find a wife," I replied.

of Gaugnin

"There are many pretty women at Faone. Do you want one?"

"Yes."

"Very well! If she pleases you, I will give her to you. She is my daughter."

"Is she young?"

"Yes."

"Is she pretty?"

"Yes."

"Is she in good health?"

"Yes."

"It is well. Go and bring her to me."

The woman went out.

A quarter of an hour later, as they were bringing on the meal, a truly Maori one of wild bananas and shellfish, she returned followed by a young girl who held a small bundle in the hand.

Through her dress of almost transparent rosecolored muslin one could see the golden skin of her shoulders and arms. Two swelling buds rose on the breasts. She was a large child, slender, strong, of wonderful proportions. But in her beautiful face I failed to find the characteristics which hitherto I had found

of Sanghin,

everywhere dominant on the island. Even her hair was exceptional, thick like a bush and a little crispy. In the sunlight it was all an orgy in chrome.

They told me that she was of Tonga origin.

I greeted her; she smiled and sat down beside me.

"Aren't you afraid of me?" I asked.

"Aïta (no)."

"Do you wish to live in my hut for always?"

"Eha (yes)."

"You have never been ill?"

"Aïta!"

That was all.

My heart beat, while the young girl on the ground before me was tranquilly arranging the food on a large banana-leaf and offering it to me. I ate with good appetite, but I was pre-occupied, profoundly troubled. This child of about thirteen years (the equivalent of eighteen or twenty in Europe) charmed me, made me timid, almost frightened me. What might be passing in her soul? And it was I, so old in contrast with her, who hesitated to sign a contract in which all the advantages were on my side, but which was entered into and concluded so hastily.

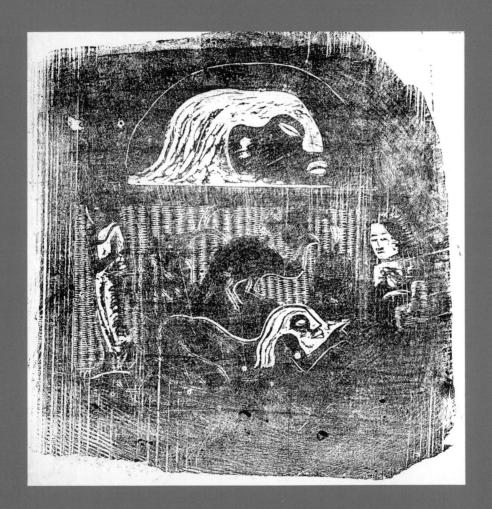

TE ATUA (VERSO) (The Gods)

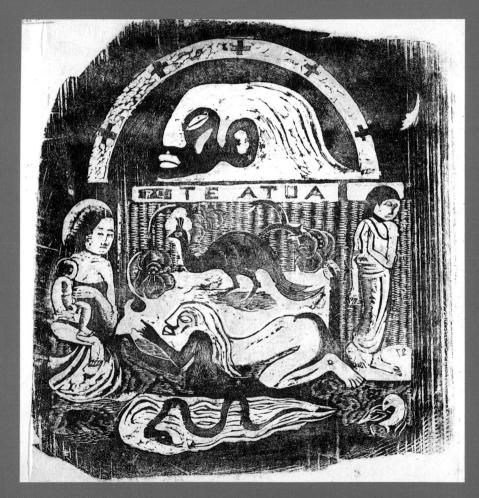

TE ATUA (RECTO) (The Gods)

of Gaughin.

Perhaps, I thought, it is in obedience to her mother's command. Perhaps, it is an arrangement upon which they have agreed among themselves....

I was reassured when I saw in the face of the young girl, in her gestures and attitude the distinct signs of independence and pride which are so characteristic of her race. And my faith was complete and unshakable, when after deep study of her, I saw unmistakably the serene expression which in young beings always accompanies an honorable and laudable act.—But the mocking line about her otherwise pretty, sensual and tender mouth warned me that the real dangers of the adventure would be for me, not for her....

I cannot deny that in crossing the threshold of the hut when leaving my heart was weighed down with a strange and very poignant anguish.

The hour of departure had come. I mounted the horse. The girl followed behind. Her mother, a man, and two young women-her aunts, she said-also followed.

We returned to Taravao, nine kilometers from Faone.

After the first kilometer, they said: *"Parahi té ié* (here stop)."

64

of Gaughin.

I dismounted from my horse, and all six of us entered into a large hut, neatly kept, almost rich—with the riches of the earth, with beautiful straw-mats.

A still young and exceedingly gracious couple lived here. My bride sat down beside the woman, and introduced me,

"This is my mother."

Then in silence fresh water was poured into a goblet from which we drank each in turn, gravely, as if we were engaged in some intimate religious rite.

After this the woman whom my bride had just designated as her mother said to me with a deeply-moved look and moist lashes,

"You are good?"

I replied, not without difficulty, after having examined my conscience,

"I hope so!"

"You will make my daughter happy?"

"Yes."

"In eight days she must return. If she is not happy she will leave you."

I assented with a gesture. Silence fell. It seemed as if no one dared to break it.

o Gaughin

Finally we went out, and again on horseback I set out, always accompanied by my escort.

On the way we met several people who were acquainted with my new family. They were already informed of the happening, and in saluting the girl they said:

"Ah, and are you now really the *vahina* of a Frenchman? Be happy!"

One point disturbed me. How did Tehura-this was my wife's name-come to have two mothers.

I asked the first one, the one who had offered her to me:

"Why did you lie to me?"

The mother of Tehura replied,

"I did not lie. The other one also is her mother, her nurse, foster-mother."

AT TARAVAO, I returned the horse to the gendarme, and an unpleasant incident occurred there. His wife, a Frenchwoman, said to me, not maliciously, but tactlessly:

"What! You bring back with you such a hussy?"

of Gaughin.

And with her angry eyes she undressed the young girl, who met this insulting examination with complete indifference.

I looked for a moment at the symbolic spectacle which the two women offered. On the one side a fresh blossoming, faith and nature; on the other the season of barrenness, law and artifice. Two races were face to face, and I was ashamed of mine. It hurt me to see it so petty and intolerant, so uncomprehending. I turned quickly to feel again the warmth and the joy coming from the glamor of the other, from this living gold which I already loved.

At Taravao the family took leave of us at the Chinaman's who sells everything—adulterated liqueurs and fruits, stuffs and weapons, men and women and beasts.

My wife and I took the stage-coach which left us twenty-five kilometers farther on at Mataïea, my home.

MY WIFE 15 not very talkative; she is at the same time full of laughter and melancholy and above all given to mockery.

O Gaughin.

We did not cease studying each other, but she remained impenetrable to me, and I was soon vanquished in this struggle.

I had made a promise to keep a watch over myself, to remain master of myself, so that I might become a sure observer. My strength and resolutions were soon overcome. For Tehura I was in a very short time an open book.

In a way I experienced, at my expense and in my own person, the profound gulf which separates an Oceanian soul from a Latin soul, particularly a French soul. The soul of a Maori is not revealed immediately. It requires much patience and study to obtain a grasp of it. And even when you believe that you know it to the very bottom, it suddenly disconcerts you by its unforeseen "jumps." But, at first, it is enigma itself, or rather an infinite series of enigmas. At the moment you believe you have seized it, it is far away, inaccessible, incommunicable, enveloped in laughter and variability. Then of its own free will it reapproaches, only to slip away again as soon as you betray the slightest sign of certitude. And when confused by its externals you seek its inmost truth, it looks at you with tranquil assurance out of the depths of

of Gaughin

its never-ending smile and its easy lightheartedness. This tranquility is, perhaps, less real than it seems.

For my part I soon gave up all these conscious efforts which so interfered with the enjoyment of life. I let myself live simply, waiting confidently in the course of time for the revelations which the first moments had refused.

A week thus went by during which I had a feeling of "childlikeness," such as I had never before experienced.

I loved Tehura and told her so; it made her laughshe knew it, very well.

She seemed to love me in return, but she never spoke of it—but sometimes at night the lightning graved furrows in the gold of the skin of Tehura....

On the eighth day—to me it seemed as though we only for the first time had entered my hut—Tehura asked my permission to visit her mother at Faone. It was something that had been promised.

I sadly resigned myself. Tying several piastres in her handkerchief in order to defray the expenses of the journey and to buy some rum for her father, I led her to the stage-coach.

I had the feeling that it was a good-by forever.

of Gaughin

The following days were full of torment. Solitude drove me from the hut and memories brought me back to it. I was unable to fix my thought upon any study....

Another week passed, and Tehura returned.

THEN A LIFE filled to the full with happiness began. Happiness and work rose up together with the sun, radiant like it. The gold of Tehura's face flooded the interior of our hut and the landscape round about with joy and light. She no longer studied me, and I no longer studied her. She no longer concealed her love from me, and I no longer spoke to her of my love. We lived, both of us, in perfect simplicity.

How good it was in the morning to seek refreshment in the nearest brook, as did, I imagine, the first man and the first woman in Paradise.

Tahitian paradise, navé navé fénua,-land of delights!

And the Eve of this paradise become more and more docile, more loving. I was permeated with her fragrance-noa noa. She came into my life at the perfect

of Gaugnin

hour. Earlier, I might, perhaps, not have understood her, and later it would have been too late. To-day I understand how much I love her, and through her I enter into mysteries which hitherto remained inaccessible to me. But, for the moment, my intelligence does not yet reason out my discoveries; I do not classify them in my memory. It is to my emotion that Tehura confides all this that she tells me. It is in my emotions and impressions that I shall later find her words inscribed. By the daily telling of her life she leads me, more surely than it could have been done by any other way, to a full understanding of her race.

I am no longer conscious of days and hours, of good and evil. The happiness is so strange at times that it suppresses the very conception of it. I only know that all is good, because all is beautiful.

And Tehura never disturbs me when I work or when I dream. Instinctively she is then silent. She knows perfectly when she can speak without disturbing me. We talk of Europe and of Tahiti, and of God and of the gods. I instruct her. She in turn instructs me.

I had to go to Papeete for a day.

I had promised to return the same evening, but the coach which I took left me half way, and I had to do

venu at qu'il devait la guitter. Se changeant 29 alors en une immense Colonne de Seu, il s'éleva magestueusement dans l'air jusqu'au dessus du Pizirere la plus haute montagne de Bora Bora ou son épouse eplorée et le peuple saisi d'étounement le perdisent de vue. On dit eufin que son fils fut un grand chef qui fit beaucoup de bien aux hommes et qu'à sa Mort il reprignit son pière au Térai suetai (Céleste sejour où ORo fit également monter Vaizantmati qui prit zang parmi les hous Déosses.

of Gaughin.

the rest on foot. It was one o'clock in the morning when I returned.

When I opened the door I saw with sinking heart that the light was extinguished. This in itself was not surprising, for at the moment we had only very little light. The necessity of renewing our supply was one of the reasons for my absence. But I trembled with a sudden feeling of apprehension and suspicion which I felt to be a presentiment—surely, the bird had flown....

Quickly, I struck a match, and I saw....

Tehura, immobile, naked, lying face downward flat on the bed with the eyes inordinately large with fear. She looked at me, and seemed not to recognize me. As for myself I stood for some moments strangely uncertain. A contagion emanated from the terror of Tehura. I had the illusion that a phosphorescent light was streaming from her staring eyes. Never had I seen her so beautiful, so tremulously beautiful. And then in this half-light which was surely peopled for her with dangerous apparitions and terrifying suggestions, I was afraid to make any movement which might increase the child's paroxysm of fright. How could I know what at that moment I might seem to her? Might she not with

O Gaughin.

my frightened face take me for one of the demons and specters, one of the Tupapaüs, with which the legends of her race people sleepless nights? Did I really know who in truth she was herself? The intensity of fright which had dominated her as the result of the physical and moral power of her superstitions had transformed her into a strange being, entirely different from anything I had know heretofore.

Finally she came to herself again, called me, and I did all I could to reason with her, to reassure her, to restore her confidence.

She listened sulkily to me, and with a voice in which sobs trembled she said,

"Never leave me again so alone without light...."

But fear scarcely slumbered, before jealousy awoke.

"What did you do in the city? You have been to see women, those who drink and dance on the marketplace, and who give themselves to officers, sailors, to all the world."

I would not quarrel with her, and the night was soft, soft and ardent, a night of the tropics....

of Gaughin

TEHURA WAS SOMETIMES very wise and affectionate, and then again quite filled with folly and frivolity. Two opposite beings, leaving out of account many others, infinitely varied, were mingled into one. They gave the lie, the one to the other; they succeeded one another suddenly with astonishing rapidity. She was not changeable; she was double, triple, multiple—the child of an ancient race.

One day, the eternal itinerant Jew, who ranges over islands as well as continents, arrived in the district with a box of trinkets of gilded copper.

He spread out his ware; every one surrounded him.

A pair of ear-rings pass from hand to hand. The eyes of the women shine; all want to possess them.

Tehura knits her brows and looks at me. Her eyes speak very clearly. I pretend I do not understand.

She draws me aside in a corner.

"I want them."

I explain to her that in France those trifles have no value whatsoever, that *they are of copper*.

"I want them."

7 Saughin

"But why? To pay twenty francs for such trash! It would be folly. No!"

"I want them."

And with passionate volubility, her eyes full of tears, she urges.

"What, would you not be ashamed to see this jewel in the ears of some other woman? Some one there is already speaking about selling his horse so that he may give the pair of ear-rings to his *vahina*."

I will have nothing to do with this folly. For the second time I decline.

Tehura looks at me fixedly, and without saying another word begins to weep.

I go away, I return, and give the twenty francs to the Jew—and the sun reappears.

Two days later was Sunday. Tehura is dressing. The hair is washed with soap, then dried in the sun, and finally rubbed down with a fragrant oil. In her best dress, one of my handkerchiefs in the hand, a flower behind the ear, the feet bare, she is going to the temple.

"And the ear-rings?" I ask.

With an expression of disdain, Tehura replies, "They are of copper."

76

R Gaugnin

And laughing aloud she crosses the threshold of the hut, and suddenly becoming grave again continues her way.

At the hour of siesta, undressed, quite simply, we sleep on this day as on other days, side by side, or we dream. In her dream Tehura, perhaps, sees gleam other ear-rings.

I-I would forget all that I know and sleep always ...

ONE DAY WHEN the weather was beautiful, God knows which day of the year it may have been for beautiful days are by no means exceptional in the Tahitian year, we decided one morning to visit friends whose hut was about ten kilometers from ours.

We left about six o'clock, and in the coolness we made such quick progress that we arrived at the early hour of eight.

We were not expected. There was great joy and when the embracings were finished, they went out in quest of a little pig to prepare a feast for us. It was slaughtered, and two chickens were added. A magnifi-

7 Saughin

cent mollusc caught that very morning, taros and bananas, made up the menu of this abundant and tempting repast.

I suggested that while waiting for noonday we visit the grottoes of Mara. I had often seen them from the distance without ever having had the opportunity of visiting them.

Three young girls, a young boy, Tehura and I, a gay little company, soon arrived at our destination.

From the edge of the way the grotto, almost wholly concealed by guavas, might be taken for a simple irregularity in the rocks or a fissure a little deeper than the others. But when you bend back the branches and glide down a meter, the sun is no longer visible. You are in a sort of cavern whose further end suggests a little stage with a bright red ceiling apparently about a hundred meters above. Here and there on the walls enormous serpents seem to extend slowly as if to drink from the surface of the interior lake. They are roots which have forced their way through the crevices in the rocks.

"Shall we take a bath?"

They reply that the water is too cold. Then there are long consultations aside and laughter which

of Gaughin.

makes me curious.

I persist; finally the young girls make up their minds and lay aside their light robes. With *pareos* around the loins, soon all of us are in the water.

There is a general cry, "Toe, toe!"

The water ripples and the cries are thrown back in a thousand echoes which repeat, "*toë*, *toë*!"

"Will you come with me?" I asked Tehura, pointing to the end of the grotto.

"Are you mad? Down there, so far. And the eels? One never goes there."

Undulant and graceful, she was disporting herself on the shore, like one very proud of her skill in swimming. But I also am a skilled swimmer. Though I did not like to venture so far entirely alone, I set out for the other end.

By what strange phenomenon of mirage was it that it seemed to recede farther from me the more I struggled to attain it? I was continually advancing, and from each side the huge serpents viewed me ironically. One moment I seemed to see a large turtle swimming, the head emerging from the water, and I distinguished two brilliant eyes fixed suspiciously on me. Absurd, I thought, sea-turtles do not live in sweet water. Never-

& Gaughin

theless (have I become a Maori in truth?) doubts assail me, and it lacks little to make me tremble. What are those large silent undulations, there, ahead of me? Eels! Come, come! We must shake off this paralyzing impression of fear.

I let myself down perpendicularly in order to touch the bottom. But I have to rise again without having accomplished it. On the shore Tehura calls to me,

"Come back!"

I turn, and I see her very far away and very small. ... Why does distance here also seem to become infinite? Tehura is nothing but a black point in a circle of light.

Angrily and stubbornly I persist. I swim for another full half hour. The end seems as far away as ever.

A resting-place on a little plateau, and then again a yawning orifice. Wither does it lead? A mystery whose fathoming I renounce!

I confess that finally I was afraid.

It needed a full hour for me to accomplish my purpose.

Tehura was waiting for me alone. Her companions having become indifferent had left.

Tehura uttered a prayer, and we left the grotto.

of Gaugnin

I was still trembling a little from the cold, but in the open air I soon recovered, especially when Tehura asked with a smile which was not wholly free from malice,

"Were you afraid?"

Boldly, I replied,

"Frenchmen know no fear!"

Tehura displayed neither pity nor admiration. But I noticed she was watching me out of the corner of her eye as I was walking a few steps in advance of her to pick a fragrant *tiare* for her bushy hair.

The road was beautiful, and the sea superb. Before us rose Morea's haughty and grandiose mountains.

How good it is to live! And with what an appetite we devour, after two hours' bath, the daintily prepared little pig which is awaiting us in the house!

A GREAT WEDDING took place at Mateiea—a real wedding, religious and legal, of the kind which the missionaries imposed upon the converted Tahitians.

I had been invited to it, and Tehura accompanied me. The meal at Tahiti, as I believe elsewhere, was

of Gaughin

the most important part of the ceremony. On Tahiti, at any rate, the greatest culinary luxury is displayed in these feasts. There are little pigs roasted on hot stones, an unbelievable abundance of fish, bananas and guavas, taros, etc.

The table at which a considerable number of guests were seated had been placed beneath an improvised roof, charmingly decorated with leaves and flowers.

All the relatives and friends of the bride and groom were present.

The young girl, the schoolmistress of the place, was half-white. She took for husband a genuine Maori, the son of the chief of Punaauïa. She had been educated in one of the "religious schools" of Papeete, and the Protestant bishop, who had taken an interest in her, had personally interceded to bring about this wedding which many regarded as a little hurried. Out here, the will of the missionary is the will of God....

For a full hour they eat, and drink much.

After this the speeches begin. There are many of these. They are delivered according to a regular order and method, and there is a curious competition in eloquence.

Then comes the important question. Which of

of Gaugnin

the two families is to give the new name to the newly married? This national custom, going back to very ancient times, is regarded as a precious, much desired, and much disputed prerogative. Not infrequently the discussion on this point degenerated into an actual battle.

On this occasion, however, there was nothing like this. Everything passed happily and peacefully. To tell the truth, all the table was pretty well intoxicated. Even my poor vahina (I could not keep my eye on her all the time), carried away by example, herself, alas, had become dead-drunk. It was not without difficulty that I finally brought her home....

At the center of the table the wife of the chief of Punaauïa throned in admirable dignity. Her pretentious and bizarre dress of orange velvet gave her vaguely the appearance of a heroine of a country fair. But the indestructible grace of her race and the consciousness of her rank lent some sort of grandeur to her tinsel. The presence of this majestic woman of very pure race at this Tahitian ceremony gave, it seemed to me, an additional pungency to the flavors of the food and the perfumes of the flowers of the island, stronger than all the others and by which all the others themselves became magnified.

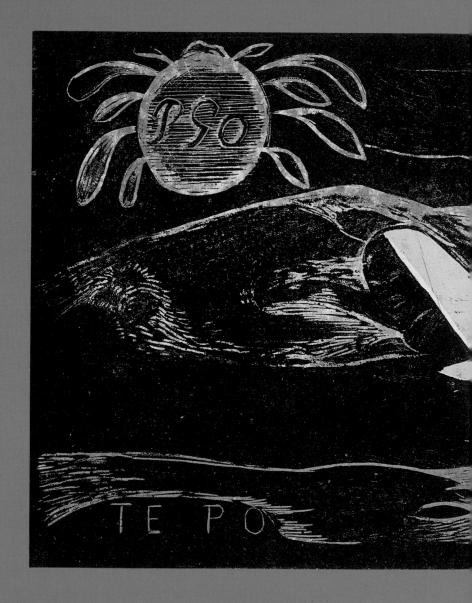

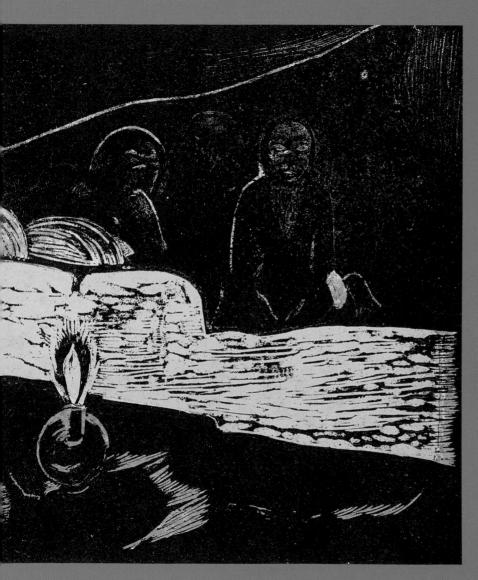

TE PO (The Long Night)

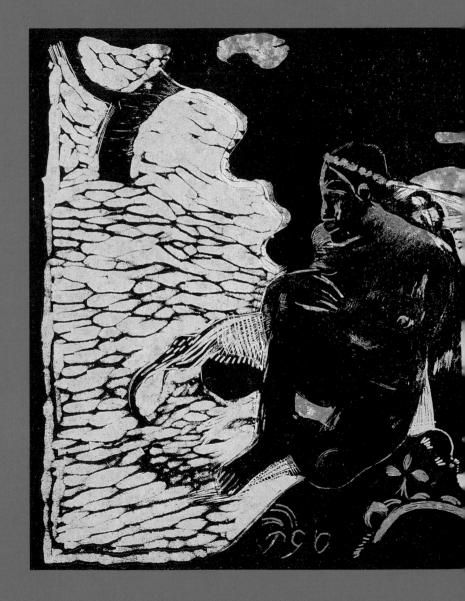

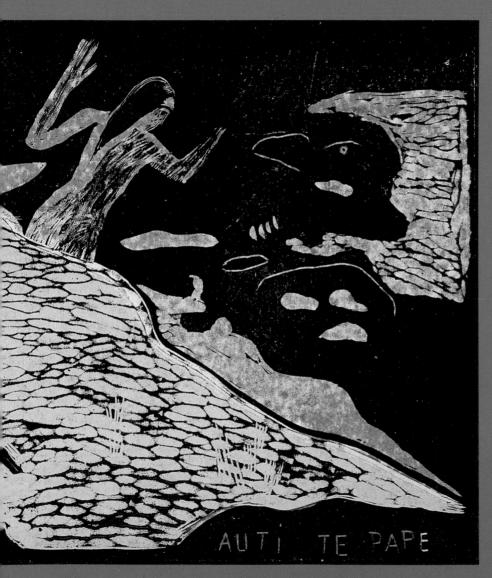

AUTI TE PAPE (Women at the River)

O Gaugnin.

Beside her sat a hundred-year-old woman, ghastly in her decrepitude which was accentuated by a double row of well preserved cannibalistic teeth. She took little interest in what was going on about her. She sat immobile and rigid, almost like a mummy. On her cheek was a tatoomarking of dark and indecisive form, but suggesting the style of a Latin letter. In my eyes it spoke for her, and told me her history. This tatooing in no way resembled that of the savages. It was surely put there by a European hand.

I made inquiries.

Formerly, they told me, the missionaries, zealous against the sin of the flesh, marked "certain women" with a seal of infamy, "signet of hell." It covered them with shame, not because of the sin committed, but because of the ridicule and opprobrium associated with such a "mark of distinction."

I understood on that day, better than I had ever done, the distrust of the Maori toward Europeans. This distrust persists even to-day, no matter how much tempered it may be by the generous and hospitable instincts of the Oceanian soul.

What a reach of years there was between this ancient woman marked by the priest, and this young

of Gaughin.

woman married by the priest! The mark remained indelible, a testimony to the defeat of the race which had submitted and to the cowardliness of the race which had inflicted it.

Five months later the young married woman brought into the world a well developed child. Outraged relatives demanded a separation. The young man declined.

"Since we love each other what does it matter? Is it not one of our customs to adopt the children of others? I adopt this one."

But why had the bishop been so anxious to hurry the marriage ceremony? There was much talk. Evil tongues insinuated that . . . There are evil tongues even on Tahiti.

IN THE EVENING we have long and often very grave conversations in bed.

Now that I can understand Tehura, in whom her ancestors sleep and sometimes dream, I strive to see and think through this child, and to find again in her the traces of the far-away past which socially is dead indeed,

O Gaughin

but still persists in vague memories.

I question, and not all of my questions remain unanswered.

Perhaps the men, more directly affected by our conquest or beguiled by our civilization, have forgotten the old gods, but in the memory of the women they have kept a place of refuge for themselves. It is a touching spectacle which Tehura presents, when under my influence the old national divinities gradually reawaken in her memory and cast off the artificial veils in which the Protestant missionaries thought it necessary to shroud them. As a whole the work of the catechists is very superficial. Their labors, particularly among the women, have fallen far short of their expectations. Their teaching is like a feeble coat of varnish which scales off, and quickly disappears at the slightest skillful touch.

Tehura goes regularly to the temple, and offers lip-service to the official religion. But she knows by heart, and that is no small task, the names of all the gods of the Maori Olympus. She knows their history, she teaches me how they have created the world, how they rule it, how they wish to be honored. She is a stranger to the rigors of Christian morals, or else she does not care. For example,

of Gaughin.

she does not think of repenting of the fact that she is the concubine, as they call it, of a *tané*.

I do not exactly know how she associates Taaroa and Jesus in her beliefs. I think that she venerates both.

As chance has come she has given me a complete course in Tahitian theology. In return I have tried to explain to her some of the phenomena of nature in accordance with European knowledge.

The stars interest her much. She asks me for the French name of the morning-star, the evening-star, and the other stars. It is difficult for her to understand that the earth turns around the sun....

She tells me the names of the stars in her language, and, as she is speaking, I distinguish by the very light of the stars who are themselves divinities in the sacred forms of the Maori masters of the air and the fire, of the islands and of the waters.

The inhabitants of Tahiti, as far as it is possible to go back in their history, have always possessed a rather extended knowledge of astronomy. The periodical feasts of the Areois, members of a secret religious and military society which ruled over the islands and of which I shall have more to say, were based on the revolutions of the

O Gaugnin.

stars. Even the nature of moonlight, it seems, was not unknown to the Maori. They assume that the moon is a globe very much like the earth, inhabited like it and rich in products like our own.

They estimate the distance from the earth to the moon in their manner thus: The seed of the tree Ora was borne from the moon to the earth by a white dove. It took her *two moons* to reach the satellite, and when after two more moons she fell upon the earth again, she was without feathers. Of all the birds known to the Maoris, this one is regarded as having the swiftest flight.

But here is the Tahitian nomenclature of the stars. I complete Tehura's lessons with the aid of a very ancient manuscript found in Polynesia.

Is it too presumptuous to see in this the beginnings of a rational system of astronomy, rather than a simple play of the imagination?

Roüa–great is his beginning–slept with his wife, the Gloomy Earth.

She gave birth to her king, the sun, then to the dusk and then to the night.

Then Roua cast off this woman.

Roüa-great is his beginning-slept with the

of Gaughin

woman called "Grande Réunion."

She gave birth to the queens of the heaven, the stars, and then to the star Tahiti, the evening-star.

The king of the golden skies, the only king, slept with his wife Fanoüi.

Of her is born the star Taüroüa (Venus), the morning-star, the king Taüroüa who gives laws to the night and the day, to the other stars, to the moon, to the sun, and serves as a guide to mariners.

Taüroüa sailed at the left toward the north, where he slept with his wife, and begat the Red Star, the star which shines in the evening under two faces.

The Red Star, flying in the East, made ready his pirogue, the pirogue of the full day, and steered toward the skies. At the rise of the sun he sailed away.

Rehoüa now arises in the wideness of space. He sleeps with his wife, Oüra Taneïpa

Of them are born the Twin-kings, the Pleiades.

These Twin-kings are surely identical with our Castor and Pollux.

This first version of the Polynesian genesis is complicated with variations which are perhaps only developments.

O Gaughin.

Taaroa slept with the woman who calls herself Goddess of the Without (or of the sea).

Of them are born the white clouds, the black clouds, and the rain.

Taaroa slept with the woman who calls herself Goddess of the Within (or of the earth).

Of them is born the first germ.

Is born in turn all that grows upon the surface of the earth.

Is born in turn the mist of the mountains.

Is born in turn he who calls himself the Strong.

Is born in turn she who calls herself the Beautiful, or the one Adorned-in-order-to-Please.

Mahoüi²launches his pirogue.

He sits down in the bottom. At his right hangs the hook, fastened to the line by strands of hair.

And this line, which he holds in his hand, and this hook, he lets fall down into the depths of the universe in order to fish for the great fish (the earth).

The hook has caught.

Already the axes show, already the God feels the enormous weight of the world.

Tefatou (the God of the earth and the earth itself)

Atomas (Inférieurs) E. Atoua maho (Dieux Requins) patron des navigateurs. Atona piero i Diaux et Déesses des vallons patron des agriculteurs. Atona no le oupaoupa. Patrons des artistés chauteurs, dramatiques, et chorequaphes. Atona zaaon pava mai (de la médeine , Atoua no apa . Dieux à qui l'ou faisait des offrandes pour sa garantin des maléfies et enchantement des sorciers. O. Fanou (Dien des faaabour ou laboureurs. Tane ité has (charpentiers de maisons piroques etc. Minia at Sapea (Patron des couvreurs) Matatini (Patron des faiseurs de filets.)

18

P Gaughin.

caught by the hook, emerges out of the night, still suspended in the immensity of space.

Mahoui has caught the great fish which swims in space, and he can now direct it according to his will.

He holds it in his hand.

Mahouï rules also the course of the sun, in such a way that day and night are of equal duration.

I asked Tehura to name the Gods for me.

Taaroa slept with the woman Ohina, the Goddess of the air.

Of them is born the rainbow, the moonlight, then, the red clouds and the red rain.

Taaroa slept with the woman Ohina, Goddess of the bosom of the earth.

Of them is born Tefatou, the spirit who animates the earth, and who manifests himself in subterranean noises.

Taaroa slept with the woman called Beyond-the-Earth.

Of them are born the Gods Teirü and Roüanoüa

Then in turn Roo who sprang from the flank of his mother's body.

of Gaugnin.

And of the same woman were also born Wrath and the Tempest, the Furious Winds, and also the Peace which follows these.

And the source of these spirits is in the place whence the Messengers are sent.

But Tehura admits that these relations are contested. The most orthodox classification is this.

The Gods are divided into Atuas and Oromatuas. The superior Atuas are all sons and grandsons of Taaroa.

They dwell in the heavens.—There are seven heavens.

Taaroa and his wife Feii Feii Maïteraï had as sons: Oro (the first of the gods after his father, and who himself had two sons, Tetaï Mati and Oüroü Tetefa), Raa (father of Tetoüa Oüroü Oüroü, Feoïto, Teheme, Roa Roa, Tehu Rai Tia Hotoü, Temoüria), Tane (father of Peüroürai, Piata Hoüa, Piatia Roroa, Parara Iti Mataï, Patia Taüra, Tane Haeriraï), Roo, Tieri, Tefatou, Roüa Noüa, Toma Hora, Roüa Otia, Moë, Toüpa, Panoüa, Tefatou Tire, Tefatou Toutaü, Peuraï, Mahoüi, Harana, Paümoüri, Hiro, Roüi, Fanoüra, Fatoühoui, Rii.

O Gaughin.

Each of these gods has his particular attributes.

We already know the works of Mahoui and Tefatou....

Tané has the seventh heaven for his mouth, and this signifies that the mouth of this god, who has given his name to man, is the farthest end of the heavens, whence the light begins to illume the earth.

Rii separated the heavens and the earth.

Roüi stirred up the waters of the ocean; he broke the solid mass of the terrestrial continent, and divided it into innumerable parts which are the present islands.

Fanoüra, whose head touches the clouds and whose feet touch the bottom of the sea, and Fatoühoüi, another giant, descended together upon Eïva-an unknown land-in order to combat and destroy the monstrous hog which devoured human beings.

Hiro, the god of thieves, dug holes in the rocks with his fingers. He liberated a virgin whom the giants held captive in an enchanted place. With one hand he snatched up the trees which during the day concealed the prison of the virgin, and the charm was broken....

The inferior Atuas are particularly occupied with the life and work of men, but they do not abide in their

of Gaugnin.

dwelling-places.

They are: the Atuas Maho (god-sharks), guardian spirits of mariners; the Peho, gods and goddesses of the valleys, guardian spirits of husbandry; the No Te Oüpas Oüpas, guardian spirits of singers, of comedians, and of dancers; the Raaoü Pava Maïs, guardian spirits of physicians; the No Apas, gods to whom offerings are made after they have protected one from witchcraft and enchantment; the O Tanoü, guardian spirits of laborers; the Tane Ite Haas, guardian spirits of carpenters and builders; the Minias and the Papeas, guardian spirits of the roofers; the Matatinis, guardian spirits of makers of nets.

The Oromatuas are household gods, the Lares.

There are Oromatuas properly so called, and Genii.

The Oromatuas punish the fomenters of strife, and preserve peace in the families. They are: the Varna Taatas, the souls of the men and women of each family who have died; the Eriorios, the souls of the children, who have died at an early age of a natural death; the Poüaras, the souls of the children, who have been killed at birth, and who have returned into the body of grasshoppers.

The Genii are conjectural divinities, or rather consciously created by man. Without apparent motive, except

of Gaughin.

that of his own choice, he attributes divine qualities to some animal or to some object, as, for example, a tree, and then he consults it in all important circumstances. There is in this, perhaps, a trace of Indian metempsychosis with which the Maoris very probably were acquainted. Their historical songs and legends abound in fables in which the great gods assume the form of animals and plants.

In the last rank of the celestial hierarchy, after the Atuas and the Oromatuas, come the Tiis.

These sons of Taaroa and Hina are very numerous.

In the Maori cosmogomy, they are spirits, inferior to the gods and strangers to men. They are intermediate between organic beings and inorganic beings and defend the rights and prerogatives of the latter against the usurpations of the former.

Their origin is this:

Taaroa slept with Hina, and of them was born Tii.

Tii slept with the woman Ani (*Desire*), and of them were born: Desire-of-the-night, the messenger of shadows and of death; Desire-of-the-day, the messenger of light and of life; Desire-of-the-gods, the messenger of the things of heaven; Desire-of-men, the messenger of the things of the earth.

of Gaugnin

Of them in turn were born: Tii of the within who watches over animals and plants; Tii of the without who guards the beings and things of the sea; Tii of the sands, and Tii of the sea-shores, and Tii of the loose earth; Tii of the rocks and Tii of the solid earth.

Still later were born: the happenings of the night, the happenings of the day, going and coming, flux and reflux, the giving and receiving of pleasure.

The images of the Tiis were placed at the farthest ends of the maraes (temples), and formed the limit which circumscribed the sacred places. They are seen on the rocks and on the sea-shores. These idols have the mission of marking the boundaries between the earth and the sea, of maintaining the balance between the two elements, and of restraining their reciprocal encroachments. Even modern travelers have seen a few statues of Tiis on the Ile-de-Pâques. They are colossal outlines partaking of human and animal forms, and bear witness to a special conception of beauty and a genuine skill in the art of working in stones, for they are architecturally constructed of superimposed blocks with original and ingenious combinations of color.

The European invasion and monotheism have

of Gaughin

destroyed these vestiges of a civilization which had its own grandeur. When the Tahitians to-day raise monuments, they achieve miracles of bad taste—as, for example, the tomb of Pomare. They had been richly endowed with an instinctive feeling for the harmony necessary between human creations and the animal and plant life which formed the setting and decoration of their existence, but this has now been lost. In contact with us, with *our school*, they have truly become "savages," in the sense which the Latin occident has given this word. They themselves have remained beautiful as masterpieces, but morally and physically (owing to us) they have become unfruitful.

SOME TRACES OF maraës still exist. They were parallelograms broken by openings. Three sides were formed of stone walls, four to six feet in height; a pyramid not as high as it was wide formed the fourth. The whole had a width of about one hundred meters, and a length of forty. Images of Tiis decorated this simple architectural structure.

of Gaughin.

THE MOON HAD an important place in the metaphysical speculations of the Maoris. It has already been stated that great feasts were celebrated in her honor. Hina is often invoked in the traditional recitals of the Areois.

But her share or rôle in the harmony of the world is negative rather than positive.

This appears clearly in the dialogue between Hina and Tefatou.

Such texts would offer beautiful material for exegists, if the Oceanian Bible could be found as a subject for commentary. They would see there first of all the principles of a religion based on the worship of the forces of nature—a characteristic common to all primitive religions. The greater number of Maori gods are in effect personifications of different elements. But an attentive glance, if not misled or depraved by a desire to demonstrate the superiority of our philosophy over that of these "tribes," would soon discover interesting and singular characteristics in these legends.

I should like to point out two, but I shall do no more than indicate them. The problem of verifying these

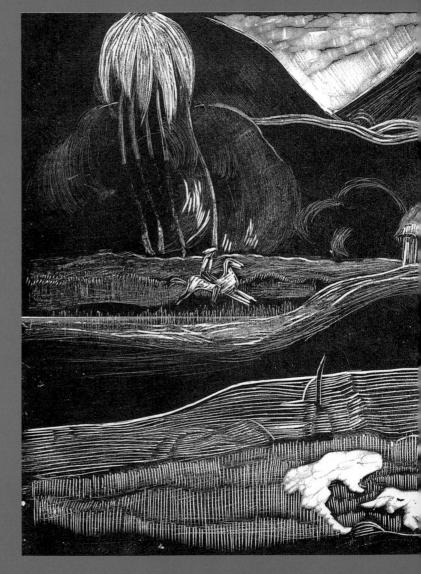

MARURU (Thank You)

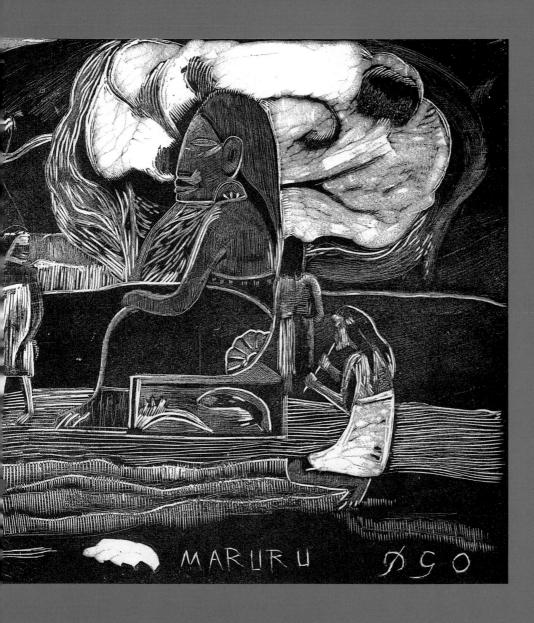

O Gaughin.

hypotheses is a matter for savants.

It is above all the clearness with which the two only and universal principles of life are designated and distinguished and ultimately resolved into a supreme unity. The one, soul and intelligence, Taaroa, is the male; the other in a certain way matter and body of the same god, is the female, that is Hina. To her belongs all the love of men, to him their respect. Hina is not the name of the moon alone. There is also a Hina-of-the-air, a Hina-of-thesea, a Hina-of-the-Within, but these two syllables characterize only the subordinate parts of matter. The sun and the sky, light and its empire, all the noble parts of matter, so to speak, or rather all the spiritual elements of matter are Taaroa. This is definitely formulated in more than one text, in which the definition of spirit and matter can be recognized. Or what, if we acquiesce in this definition, is the significance of the fundamental doctrine of the Maori genesis:

> THE GREAT AND HOLY UNIVERSE IS ONLY THE SHELL OF TAAROA-?

of Gaughin.

Does not this doctrine constitute a primitive belief in the unity of matter? Is there not in this definition and separation of spirit and matter an analysis of the twofold manifestations of a single and unique substance? However rare such a philosophical intention may be among primitives, it does not follow that one should decline to receive testimony. It is evident that the Oceanian theology had two ends in view in the actions of the god who created the world and conserves it: the generative cause and matter which has become fecund, the motive force and the object acted upon, spirit and matter. It also appears clearly that in the constant interaction between the luminous spirit and the perceptive matter which it vivifies-that is to say in the successive unions of Taaroa with the diverse manifestations of Hina-one should recognize the continual and ever-varying influence of the sun upon things. And in the fruits of these unions are to be seen the changes continually effected in these very elements by light and warmth. When once we have a clear view of this phenomenon out of which the two universal currents proceed, we see that in the fruit are united and mingled the generative cause and the matter which has become fecund, in movement, the motive force and

o Gaughin

the object acted upon, and in life, spirit and matter, and that the universe just created is only the *shell of Taaroa*.

In the second place it appears from the dialogue between Tefatou and Hina, that man and earth shall perish, but that the moon and the race inhabiting it shall continue. If we recall that Hina represents matter, and that according to the scientific precept, "all things transform but nothing perishes," we must agree that the old Maori sage who invented the legend knew as much about the subject as we do. Matter does not perish, that is to say it does not lose the qualities which can be perceived by the senses. Spirit, on the contrary, and light, this "spiritual matter," are subject to transformation. There is night and there is death, when the eyes close, from which light seemed to radiate and to reflect. Spirit, or rather the highest actual manifestation of spirit, is man. "Man must die . . . he dies never to rise again. . . . And man should die." But even when man and the earth, these fruits of the union of Taaroa and Hina, have perished, Taaroa himself will remain eternal, and we are told that Hina, matter, will also continue to be. There will then necessarily be present throughout all eternity spirit and matter, light and the object which it strives to illumine.

of Gaughin.

They will be urged on with a mutual desire for a new union from which will arise a new "state" in the infinite *evolution* of life.

Evolution! . . . The unity of matter! . . . Who would have thought to find such testimony of a high civilization in the conceptions of former cannibals? I can with good conscience say that I have added nothing to the truth.

It is true that Tehura had no doubts concerning these abstractions, but she persisted in regarding shooting stars as wandering tupapaüs and genii in distress. In the same spirit as her ancestors, who thought that the sky was Taaroa himself and that the Atuas descended from Taaroa were simultaneously gods and heavenly bodies, she ascribed human feelings to the stars. I do not know in how far these poetic imaginings impede the progress of the most positive science, neither do I know to what point the highest science would condemn them.

From other points of view it would be possible to give other interpretations to the dialogue between Tefatou and Hina: The counsel of the moon who is feminine might be the dangerous advice of blind pity and sentimental weakness. The moon and women, expressions in the

of Gaughin

Maori conception for matter, need not know that death alone guards the secrets of life. Tefatou's reply might be regarded as the stern, but far-sighted and disinterested, decree of supremest wisdom, which knows that the individual manifestations of actual life must give way before a higher being in order that it may come and must sacrifice themselves to it in order that it may triumph.

In earlier days this response would have had a much more far-reaching implication and the import of a national prophecy. A great spirit of ancient days would have studied and measured the vitality of his race; he would have foreseen the germs of death in its blood without the possibility of recovery or rebirth, and he would have said:

Tahiti will die, it will die never to rise again.

TEHURA SPOKE WITH a kind of religious dread of the sect or secret society of the Areois, which ruled over the islands during the feudal epoch.

Out of the confused discourse of the child I disentangle memories of a terrible and singular institution. I

of Gaugnin

divine a tragic history full of august crimes, but which it is difficult to penetrate because it is guarded from the curious by a well kept secret.

After Tehura had told me all she knew on this subject, I made inquiries wherever possible.

The legendary origin of this famous society is as follows:

Oro, the son of Taaroa, and after his father the greatest of the gods, resolved one day to choose a mate from among the mortals.

He wished her to be a virgin and beautiful, to the end that he might found with her among the multitude of men a race superior and favored above all others.

He strode through the seven heavens and descended upon Païa, a high mountain on the island of Bora-Bora, where dwelt his sisters, the goddesses Teouri and Oaaoa.

Oro, transformed into a young warrior, and his sisters into young girls, set out upon a journey through the islands to find there the creature deserving of the kiss of a god.

Oro snatched up the rainbow, and placed one end upon the summit of Païa and the other upon the earth; thus

of Gaughin

the god and the goddesses passed over valleys and tides.

In the different isles where people hastened to welcome the fair and magnificent visitors, the travelers gave marvelous feasts to which all the women flocked.

And Oro gazed upon them.

But his heart was filled with sadness, for the god found love, but he did not love. His glance did not remain long upon any of the daughters of men; in not a single one did he find the virtues and graces of which he had dreamed.

And after many days had been consumed in vain search, he decided to return to heaven, when he saw at Vaïtape on the island of Bora-Bora a young girl of rare beauty bathing in the little lake of Avaï Aïa.

She was tall in stature, and all the fires of the sun burned and shone in the splendor of her flesh, while all the magic of love slept in the night of her hair.

Enchanted, Oro prayed his sisters to speak to the young girl for him.

He himself retired to the summit of Païa to await the result of their embassy.

The goddesses in approaching the young woman saluted her, praised her beauty, and told her that they

of Gaughin.

came from Avanaü, a place on Bora-Bora.

"Our brother asks of you whether you will consent to become his wife."

Vaïraümati-for so the girl was named-carefully scrutinized the strangers, and said to them,

"You are not from Avanaü, but that does not matter. If your brother is a chief, if he is young and beautiful, let him come. Vaïraümati will be his wife."

Without delay Teouri and Oaaoa ascended Païa to tell their brother that he was awaited.

Then Oro, placing the rainbow again as at first, came down to Vaïtape.

Vaïraümati had prepared for his reception a table weighed down with the most beautiful fruits, and a couch of the rarest stuffs and the finest of mats.

And divine in their grace and strength they offered service to love under the tamaris and pandanus, in the forest and on the edge of the sea. Every morning the god reascended the summit Païa; every evening he came down again to sleep with Vaïraümati.

No other daughter of men henceforth was permitted to see him in human form.

And always the rainbow extended between Paia

ORO charme de sa nouvelle épouse, retournait chaque matin au sommet du Saia et redescendait chaque soin sur l'are au cicl chez vairaumati. Il restra longtemps absent du Terai (ciel, . Orotéfa et Eurétefa ses frères, descendus comme lui du Céleste Séjour par la courbe de l'Arcenciel après l'avoir longtemps cherché dans les différentes îles le découvrirent cufin avec son amante dans l'île de Bora Bora, afois à l'ombre d'un arbre sacré,

of Gaughin.

and Vaïtape served him as a way of passage.

Many moons had shone and become extinguished, and in the deserted Seven Heavens no one knew where was the retreat of Oro. Two other sons of Taaroa, Orotefa and Oürtefa, took on human form and set out to find their brother. For a long time they wandered hither and thither among the islands without finding him. Finally, approaching Bora-Bora, they saw the young god sitting with Vaïraümati in the shadow of a sacred mango-tree.

They marveled at the beauty of the young woman, and wished to give her presents as a testimony of their admiration. Orotefa transformed himself into a sow, and Oürtefa into red feathers. Immediately taking on human form again, while the sow and the feathers remained, they approached the two lovers, bearing these presents in their hand.

Oro and Vaïraümati welcomed the two august travelers with joy.

That same night the sow threw a litter of seven. The first of these was reserved for a later purpose; the second was sacrificed to the gods; the third was consecrated to hospitality and offered to strangers; the fourth they named Pig of the Hecatomb, in honor of love; the fifth

of Gaughin.

and sixth were to be preserved for the purpose of multiplying the species until after the first litter; and finally the seventh was roasted entire on hot-stones (according to the Maori custom thus divinely inaugurated), and then eaten.

The brothers of Oro returned to the heavens.

A few weeks later Vaïraümati told Oro that she was about to become a mother.

Then Oro took the first of the seven pigs which had been spared, and went to Raïatea to the great *maraë* the temple of the god, Vapoa.

There he encountered a man, Mahi by name, to whom he gave the pig, saying,

"*Maiï maitaï oe teineï boüaa* (take this pig and guard it well)."

And solemnly the god continued,

"This is the sacred pig. In its blood will be dyed the league of men who shall spring from me. For I am father in this world. These men shall be the Areois. To thee I give their prerogatives and their name. As for myself I can no longer stay here."

Mahi sought out the chief of Raïatea, and told him of the happening. But, as he could not guard the sacred trust without being the friend of the chief, he added,

O Gaughin.

"My name shall be thy name, and thy name shall be mine."

The chief agreed, and together they took the name Taramanini.

In the meantime Oro, having returned to Vaïraümati, announced to her that she would bring forth a son, and commanded she name him Hoa Tabou té Raï (sacred friend of the heavens).

Then he said:

"The fullness of time has come, and I must leave thee."

Immediately he changed into an immense pillar of fire, which majestically rose into the air even above Perirere which is the highest mountain of Bora-Bora. There he disappeared from the view of his weeping wife and the astonished people.

Hoa Tabou té Raï became a great chief, and did much good toward man. At his death he was raised to heaven, where Vaïraümati herself ranked among the goddesses.

of Gaughin

ORO MAY VERY well have been a wandering Brahmin who brought to these islands the doctrine of Brahma to the traces of which in the Oceanian religion I have already referred. When?...

In the purity of this doctrine the Maori genius had its awakening. Minds capable of comprehending recognized each other and became associated for the practice of the prescribed rites, naturally quite apart from the common people. More enlightened than the other men of their race, they soon seized hold of the religious and political government of the island. They arrogated to themselves important prerogatives and established a powerful feudal state which was the most glorious period in the history of the archipelago.

Though apparently they were ignorant of the art of writing, the Areois nevertheless were men of learning. They passed entire nights in reciting scrupulously word by word the ancient "sayings of the gods." Their text has now become established, but this could not have been accomplished except at the cost of years of assiduous labor. The Areois alone had access to these sayings of the

o Gaugnin

gods, and at the most were only permitted to add commentaries. It gave them the security of an intellectual center, the habit of meditation, the authority of a superhuman mission, and a prestige before which all the others bowed their heads.

There are in our Christian and feudal Middle Ages very similar institutions, as the reader knows. For myself I know nothing more frightful than the religious and military association, the permanent council of that period, which rendered judgments in the name of God and held absolute power over life and death.

The Areois taught that human sacrifices are pleasing to the gods, and they themselves sacrificed in the *maraës* all their children save the first-born. This bloody rite was symbolized by the seven pigs of the legend, all of which except the first, the "sacred pig," were put to death.

Let us not be overhasty in criticizing this as savagery. This cruel obligation which many other primitive peoples also had to obey has deep-lying social and general causes. Among very prolific races, such as the Maori race formerly was, unlimited increase of the population is a menace to existence itself, both national and personal. Doubtless life on the islands was easy enough, and it did

7 Sauguin

not require much effort to obtain the necessities for subsistence. But the area was very restricted, and surrounded by an immense ocean, impassable to frail pirogues. It would soon have been insufficient for a people continually increasing. There would not have been sufficient fish in the sea, nor sufficient fruit in the forest. Famine would not have long delayed, and as always everywhere in the world would have had cannibalism as a consequence.

To avoid the murder of men, the Maoris resigned themselves to the killing of children. Let us note besides that cannibalism was already a custom when the Areois appeared, and that to combat it and to destroy its causes they introduced infanticide. One might say that infanticide already constituted a distinct mitigation in their customs, even though the sinister humor of this observation might serve as a subject for the amusement of a vaudevillist. Doubtless the Areois had to exercise extraordinary energy to accomplish even this degree of progress. Probably they were able to achieve it only by assuming unto themselves in the eyes of the people all the authority of the gods.

Ultimately infanticide was a potent means of selection for the race. The terrible right of primogeniture, which was the right to life itself, kept the strength of the

of Gaugnin.

race intact in that it protected it from the malign influence of an exhausted blood. It kept alive furthermore in all these children from their earliest youth a consciousness of unalterable pride. The primitive force and the last flower of this pride are what we still admire in the last scions of a great but dying race.

The constant spectacle and the frequent return to death was finally an austere but vivifying doctrine. The warriors learned to despise pain, and the entire nation obtained from it an intense emotional benefit which preserved it from tropical enervation and the languor of perpetual idleness. It is a historic fact that from the day on which sacrifice was forbidden by law the Maoris began to decline and finally lost all their moral vitality and physical fruitfulness. Even if this was not the cause, the coincidence, at least, remains a subject for thought.

Perhaps the Areois even understood the deeper virtue and symbolic necessity of sacrifice....

In the society of the Areois, prostitution was a sacred duty. We have changed that. Prostitution has not ceased on Tahiti since we have heaped upon it the benevolences of our civilization. On the contrary it prospers. It

O Gaughin.

is neither obligatory nor sacred. It is simply inexcusable and without grandeur.

The religious dignity descended from father to son, and the initiation began in infancy.

The society was originally divided into twelve lodges, which had as grand-masters the twelve first Areois. Then came the dignitaries of second rank, and finally the apprentices. The different grades were distinguished by special tatoo-markings on the arms, the sides of the body, the shoulders, and the ankle-joints.

The *Matumua* of the Areois is a Maori scene of ancient times which took place at the enthronement of the king.

The new ruler leaves the palace dressed in sumptuous robes, surrounded by the chief men of the island. The grand-masters of the Areois precede him with rare feathers in the hair.

He goes with his train of attendants to the marae.

When the priests, waiting on the threshold, see him, they proclaim with loud sounding of trumpets and drums that the ceremony has begun.

Then when the king has entered the temple they place a human sacrifice, a corpse, before the idol of the god.

of Gaughin.

The king and the priests recite and sing prayers in unison, whereupon the priest tears out the two eyes from the sacrifice. He offers the right eye to the god, and the left to the king, who opens the mouth as if to swallow the bloody eye, but the priest forthwith withdraws it, and places it with the rest of the body.³

The statue of the god is placed upon a carved litter borne by the priests. Seated upon the shoulders of the chief priest, the king then follows the idol as far as the seashore, accompanied by the Areois, as though he were about to set out on a journey. Dancing, along the entire way, the priests do not cease sounding the trumpet and beating the drum. The multitude follows behind, silently and reverently.

The sacred pirogue undulates gently in a little bay on the seashore. It has been decorated for this ceremony with green branches and flowers. The idol is first placed aboard. Then the king is disrobed of his vestments, and the priests lead him into the sea, where among the waves the Atuas Maho (god-sharks) come to caress and lave him.

Thus consecrated a second time by the kiss of the sea under the eyes of the god, as he was the first time in

46 de lours trompettes étélattre de leurs tambours, ce qui était le signal de la retraite et de la fin de la fête. Le roi retournait alors à sa demeure, accompagné de sa suite.

of Gaugnin

the temple by the god himself, the king ascends into the pirogue. There the high priest girds his loins with the *maroüroü*, and places around his head the *taoü mata*. They are the bands of sovereignty.

Standing upright on the prow of the sacred pirogue, the king shows himself to the people.

And at this sight the people finally break their long silence, and everywhere the solemn cry resounds.

"Maeva Arii (long live the king)!"

When the first tumult of joy has subsided, the king is placed upon the sacred couch where just now the idol has been. Then they take up their way to the marae again, almost in the same order of procession in which they came.

The priests again bear the idol. The chiefs bear the king. They open the procession again with their music and dancing.

The people follow behind. But now having given themselves over to joy they cry continually,

"Maïva Arii!"

The idol is solemnly replaced on its altar.

With this the religious ceremony is at an end, and now the popular celebration begins.

O Gaughin.

Just as he held communion with the gods in the temple, and with nature in the sea, so the king must now hold communion with his people.⁴ The king, couched on mats, now receives *the highest homage of the people*.

It is the frenzied homage of a savage people.

The entire multitude expresses its love for *a man*, and that man is the king. Grandiose even to the point of horror and terror is this spectacle which is like a dialogue between a man and the multitude. To-morrow he will be supreme master, freely able to dispose over the destinies of those subject to him, and all the future is his. The multitude has only this hour.

Men and women, entirely naked, circle around the king dancing lascivious dances. They strive to touch certain parts of his body with certain parts of theirs. It is not always possible to avoid contacts or to keep from contamination. The frenzy of the people increases; it turns into madness. The peaceful island vibrates with frightful cries. The falling evening shows the fantastic spectacle of a multitude in ecstatic madness.

Suddenly the sound of the sacred trumpet and drum is heard again.

The homage is at an end, the festival is over; the

of Gaughin

signal of retreat has sounded. Even the most delirious obey, and all subside. There is an abrupt, absolute silence.

The king rises; solemnly and majestically he reënters the palace, accompanied by his suite.

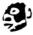

SINCE ABOUT A fortnight there have been swarms of flies which are rare at other times, and they have become insupportable.

But the Maoris rejoice. The bonitoes and tunnyfish are coming to the surface. The flies proclaim that the season for fishing is at hand, the season of labor. But let us not forget that on Tahiti work itself is pleasure.

Ever one was testing the strength of his lines and hooks. Women and children with unusual activity busied themselves in dragging nets, or rather long grates of cocoanut leaves, upon the seashore, and the corals which occupied the sea bottom between the land and the reefs. By this method certain small bait-fish of which the tunnyfish are fond are caught.

After the preparations have been completed, which takes not less than three weeks, two large pirogues

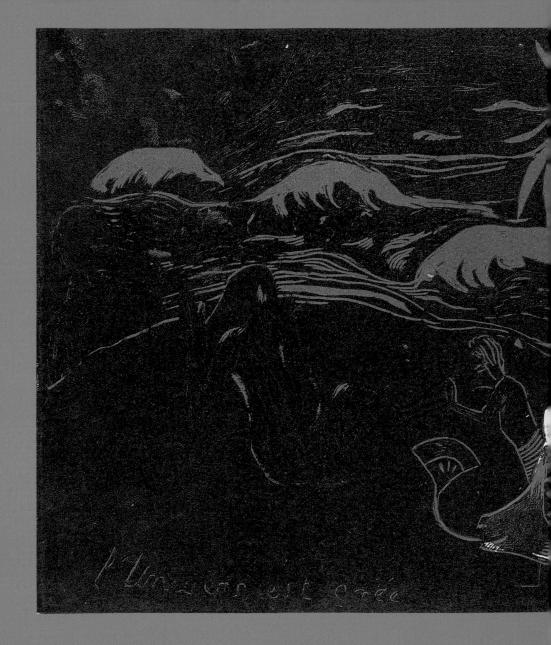

L'UNIVERS EST CRÉE (The Universe is Created)

of Gaugnin

are tied together and launched upon the sea. They are furnished at the prow with a very long rod, which can be quickly raised by means of two lines fixed behind. The rod is supplied with a hook and bait. As soon as a fish has bitten it is drawn from the water and stored in the boat.

We set out upon the sea on a beautiful morningnaturally I participated in the festival-and soon were beyond the line of reefs. We ventured quite a distance out into the open sea. I still see a turtle with the head above water, watching us pass.

The fishermen were in a joyful mood, and rowed lustily.

We came to a spot which they called "tunny-hole" where the sea is very deep, opposite the grottoes of *Mara.*⁵

There, it is said, the tunny-fish sleep during the night at a depth inaccessible to the sharks.

A cloud of sea-birds hovered above the hole on the alert for tunnies. When one of the fish appeared the birds dashed down with unbelievable rapidity, and then rose again with a ribbon of flesh in the beak.

Thus everywhere in the sea and in the air, and even in our pirogues carnage is contemplated or carried out.

When I ask my companions why they do not let a

of Gaughin.

long line down to the bottom of the "tunny-hole," they reply to me that it is impossible since it is a sacred place.

"The god of the sea dwells there."

I suspect that there is a legend behind this, and without difficulty I succeed in getting them to tell it to me.

ROÜA HATOU, a kind of Tahitian Neptune, slept here at the bottom of the sea.

A Maori was once foolhardy enough to fish here, and his hook caught in the hair of the god, and the god awoke.

Filled with wrath he rose to the surface to see who had the temerity to disturb his sleep. When he saw that the guilty one was a man, he decided that all the human race must perish to explate the implety of one.

By some mysterious indulgence, however, the author himself of the crime escaped punishment.

The god ordered him to go with all his family upon *Toa Marama*, which according to some is an island or a mountain, and according to others a pirogue or an "ark."

When the fisher and his family had gone to the designated place, the waters of the ocean began to rise.

Gaughin

Slowly they covered even the highest mountains, and all the living perished except those who had taken flight upon (or in) *Toa Marama*.

Later they repeopled the islands.⁶

We left the "tunny-hole" behind us, and the master of the pirogue designated a man to extend the rod over the sea and cast out the hook.

We waited long minutes but not a bite came.

It was now the turn of another oarsman; this time a magnificent tunny-fish bit and made the rod bend downward. Four powerful arms raised it by pulling at the ropes behind, and the tunny appeared on the surface. But simultaneously a huge shark leaped across the waves. He struck a few times with his terrible teeth, and nothing was left on the hook except the head.

The master gave a signal. I cast out the hook.

In a very short time we caught an enormous tunny. Without paying much attention to it, I heard my companions laughing and whispering among themselves. Killed by blows on the head the animal quivered in its death agony in the bottom of the boat. Its body was transformed into a gleaming many-faceted mirror, sending out the lights of a thousand fires.

of Gaugnin

The second time I was lucky again.

Decidedly, the Frenchman brought good luck. My companions joyously congratulated me, insisted that I was a lucky fellow, and I, quite proud of myself, did not make denial.

But amid all this unanimity of praise, I distinguished, as at the time of my first exploit, an unexplained whispering and laughter.

The fishing continued until evening.

When the store of small bait-fish was exhausted, the sun lighted red flames on the horizon, and our pirogue was laden with ten magnificent tunny-fish.

They were preparing to return.

While things were being put in order, I asked one of the young fellows as to the meaning of the exchange of whispered words and the laughter which had accompanied my two captures. He refused to reply. But I was insistent, knowing very well how little power of resistance a Maori has and how quickly he gives in to energetic pressure.

Finally he confided in me. If the fish is caught with the hook in the lower jaw—and both my tunnies were thus caught—it signifies that the *vahina* is unfaith-

dans les montagnes; enfin alle les découvrit; mais ils se sauverent devant elle jusqu'au Sommet de la plus haute montagne ; et de là , au moment , où toute éphorée elle croyait enfin les attendre, ils s'envalaient vers les cieux, où ils figurent encore parmi les constellations. Il est certain aussi que leur Atouchi qui vient dans les mages montonnés, est notre étoile du Bergen; et que leur naounou oura, qui brille le soir sous deux faces, est notre Sagittaire, que les anciens ont quelquefois représente sous cette forme.

43 Nomination d'un Roi. Le nouveau, chef sortait de chez lui couvert de riches vétements, entouré de tous les dignitaires de l'île et précédé des principaux A Révis la tête ornée de plumes les plus rares. Il se rendait au Marai. aussitet que les prêtres qui avaient donné le signal de la cérémonie par le son des trompettes et du tambour étaient rentrés dans le temple on placait une victime humaine moste devant l'image du Dien. Le Roi et les Prétres commencaient alors des prieres des chants ; après quoi le grand prêtre s'approchait de la victime humaine et lui arrachait les deux yeux dont il déposait le droit devant l'image des Dieux et offrait le ganche au Roi qui ouvrait la bouche comme pour l'avaler, mais le prêtre le retirait de Suite pour le jourdre au reste du Corps comme il a deja' été d'ailleurs. Après ces carémonies f'image du Dieu était posée sur un brancard Soulpté ; et précédé de cette image portée par des prêtres le nouveau chef assis lui même sur les épaules de quelques chafs partait en procession pour le rivage ou se trouvait la piroque sacre

O Gaugnin.

ful during the *tané's* absence.

I smiled incredulously.

And we returned.

Night falls quickly in the tropics. It is important to forestall it. Twenty-two alert oars dipped and re-dipped simultaneously into the sea, and to stimulate themselves the rowers uttered cries in rhythm with their strokes. Our pirogues left a phosphorescent wake behind.

I had the sensation of a mad flight. The angry masters of the ocean were pursuing us. Around us the frightened and curious fish leaped like fantastic troupes of indefinite figures.

In two hours we were approaching the outermost reefs.

The sea beats furiously here, and the passage is dangerous on account of the surf. It is not an easy maneuver to steer the pirogue correctly. But the natives are skillful. Much interested and not entirely without fear I followed the operation which was executed perfectly.

The land ahead of us was illumined with moving fires. They were enormous torches made of the dry branches of the cocoanut-trees. It was a magnificent picture. The families of the fishermen were awaiting us on

of Gaugnin.

the sand on the edge of the illumined water. Some of the figures remained seated and motionless; others ran along the shore waving the torches; the children leaped hither and thither and their shrill cries could be heard from afar.

With powerful movement the pirogue ran up on the sand.

. Immediately they proceeded to the division of the booty.

All the fish were laid on the ground, and the master divided them into as many equal parts as there were persons—men, women, and children—who had taken part in the fishing for the tunnies or in the catching of the little fish used for bait.

There were thirty-seven parts.

Without loss of time, my vahina took the hatchet, split some wood, and lighted the fire while I was changing clothes and putting on some wraps on account of the evening chill.

One of our two parts was cooked; her own Tehura put away raw.

Then she asked me fully about the various happenings of the day, and I willingly satisfied her curiosity. With child-like contentment she took pleasure in everything,

O Gaughin

and I watched her without letting her suspect the secret thoughts which were occupying me. Deep down within me without any plausible cause, a feeling of disquietude had awakened which it was no longer possible to calm. I was burning to put a certain question to Tehura, a certain question . . . and it was vain for me to ask myself, "To what good?" I, myself, replied, "Who knows?"

S)

THE HOUR OF going to bed had come, and, when we were both stretched out side by side, I suddenly asked,

"Have you been sensible?"

"Yes."

"And your lover to-day, was he to your liking?"

"I have no lover."

"You lie. The fish has spoken."

Tehura raised herself and looked fixedly at me. Her face had imprinted upon it an extraordinary expression of mysticism and majesty and strange grandeur with which I was unfamiliar and which I would never have expected to see in her naturally joyous and still almost child-like face.

of Gaughin

The atmosphere in our little hut was transformed. I felt that something sublime had risen up between us. In spite of myself I yielded to the influence of Faith, and I was waiting for a message from above. I did not doubt that this message would come; but the sterile vanity of our skepticism still had its influence over me, in spite of the glowing sureness of a faith like this rooted though it was in some superstition or other.

Tehura softly crept to our door to make sure that it was tightly shut, and having come back as far as the center of the room she spoke aloud this prayer:

> Save me! Save me! It is evening, it is evening of the Gods! Watch close over me, Oh my God! Watch over me, Oh my Lord! Preserve me from enchantments and evil

counsels.

Preserve me from sudden death, And from those who send evil and curses; Guard me from quarrels over the division of the lands,

That peace may reign about us! Oh my God, protect me from raging warriors!

Etymologie de Taaroa. Jaa - Loin ctendue - Roa - Très . Dieux _ Espèces de Dieux _ Atouas . Atomas et Oromatomas. Atomas superieurs_ Ils residaient dans les Cieux. Priérarchie de pouvoirs. Cieux différents_ Sept cieux. Terai Toue tai, Terai toue roua etc... un deux trois s. Le septième était Terai ama ma tané_ La bouche de Tané. (La porte de l'extrêmité par ou entrait la lumière _ Cous étaient fils ou petits fils de Taaroa.

of Sanghin.

Protect me from him who in erring threaten's me,

Who takes pleasure in making me tremble, Against him whose hairs are always bristling! To the end that I and my soul may live, Oh my God!

That evening, I verily joined in prayer with Tehura.

When she had finished her prayer, she came over to me and said with her eyes full of tears,

"You must strike me, strike me many, many times."

In the profound expression of this face and in the perfect beauty of this statue of living flesh, I had a vision of the divinity herself who had been conjured up by Tehura.

Let my hands be eternally cursed if they will raise themselves against a masterpiece of nature!

Thus naked, the eyes tranquil in the tears, she seemed to me robed in a mantle of orange-yellow purity, in the orange-yellow mantle of Bhixu.

She repeated,

"You must strike me, strike me many, many times; otherwise you will be angry for a long time and

of Gaugnin.

you will be sick."

I kissed her.

And now that I love without suspicion and love her as much as I admire her, I murmur these words of Buddha to myself,

"By kindness you must conquer anger; by goodness evil; and by the truth lies."

That night was divine, more than any of the others and the day rose radiant.

Early in the morning her mother brought us some fresh cocoanuts.

With a glance she questioned Tehura. She *knew*. With a fine play of expression, she said to me,

"You went fishing yesterday. Did all go well?" I replied,

"I hope soon to go again."

of Sanghin.

was competied to return to France. Imperative family affairs called

me back.

Farewell, hospitable land, land of delights, home of liberty and beauty!

I am leaving, older by two years, but twenty years younger; more *barbarian* than when I arrived, and yet much *wiser*.

Yes, indeed, the savages have taught many things to the man of an old civilization; these ignorant men have taught him much in the art of living and happiness.

Above all, they have taught me to know myself better; they have told me the deepest truth.

Was this thy secret, thou mysterious world? Oh mysterious world of all light, thou hast made a light shine within me, and I have grown in admiration of thy antique beauty, which is the immemorial youth of nature. I have become better for having understood and having loved thy human soul-a

MAHNA NO VARUA INO (The Devil Speaks)

of Gaughin

flower which has ceased to bloom and whose fragrance no one henceforth will breathe.

Ş

AS I LEFT the quay, at the moment of going on board, I saw Tehura for the last time.

She had wept through many nights. Now she sat worn-out and sad, but calm, on a stone with her legs hanging down and her strong, lithe feet touching the soiled water.

The flower which she had put behind her ear in the morning had fallen wilted upon her knee.

Here and there were others like her, tired, silent, gloomy, watching without a thought the thick smoke of the ship which was bearing all of us-lovers of a day-far away, forever.

From the bridge of the ship as we were moving farther and farther away, it seemed to us that with the telescope we could still read on their lips these ancient Maori verses,

of Gaughin

Ye gentle breezes of the south and east That join in tender play above my head, Hasten to the neighboring isle. There you will find in the shadows of his favorite tree, Him who has abandoned me. Tell him that you have seen me weep.

THE END

of Saughin.

FOOTNOTES

¹ The girdle of the natives, their only article of attire.

² This Mahoui seems to be confused with Taaroa, and also with Roua who created the stars. They are perhaps different names for the same God.

³ It is impossible to misunderstand the symbolic significance of this rite. It is clearly prohibition of cannibalism.

⁴ It is to be feared that the missionaries by whom the record of the traditions has been handed down to us have calumniated the ancestors of their flock on this point as on many others for a purpose which can easily be divined. But in spite of all that is brutal, grotesque, and even repulsive, one must agree that, perhaps, this supreme rite did not lack a peculiar beauty.

⁵ This word *mara* is found in the language of the Buddhists, where it signifies *death*, and by extension *sin*.

⁶ This legend is one of the numerous Maori explanations of the Deluge.

of Gaughin.

PAINTING ACKNOWLEDGMENTS

The following are from Paul Gauguin's Noa Noa Suite; all from the Rosenwald Collection, © 1992 National Gallery of Art, Washington, D.C.

Manao Tupapau (She Is Haunted by a Spirit), 1894/1895; Maruru (Thank You), 1894/1895; The Universe is Created (L'Univers est crée), 1894; Nave Nave Fenua (Delightful Land), 1894/1895; Auti te Pape (Women at the River), 1894/1895; Noa Noa (Fragrant Fragrant), 1894/1895; Te Atua (The Gods), Small Plate, in or after 1895; Mahna no Varua Ino (The Devil Speaks), 1894/1895; Te Farurur (They Are Making Love Here), 1894/1895; Te Po (The Long Night), 1894/1895.

All unlabeled art is from *Culte Ancien Mahori*, The Noa Noa Sketchbooks.

Sur le Toa marama, qui, d'après les unsect " une piroque, d'après les autres une île ou une montagne, mais que je nommerai Azche, remarquant Seulement que TOA Marama Signifie querrier de la Lune, ce qui me fait supposer que l'Arche quelconque et l'ensemble de l'évenement du catachysme out quelque rapport avec la dune. Quand le pêcheur et sa famille se furent rendus à l'endroit indiqué, les eaux de la Mer commencerent à monter ; et couvrant jusqu'auxe montagnes les plus élèvées, firent périr tous les êtres, à l'exception de ceux qui étainet sur ou dans le Toa marama, et qui, plus tard, repenplerent les îles ou la terre.